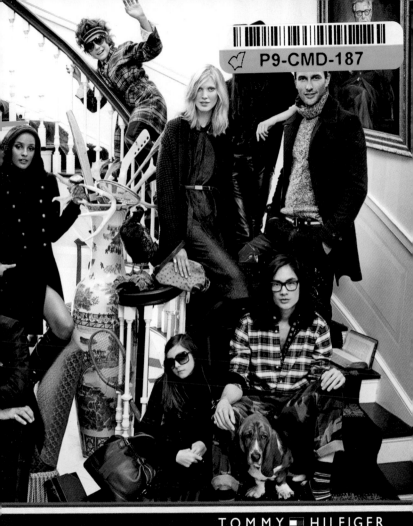

P9-CMD-187

TOMMY ■ HILFIGER

COOL
NEW YORK

teNeues

PRICE CATEGORY

$ = BUDGET $$ = AFFORDABLE $$$ = MODERATE $$$$ = LUXURY

COOL
CONTENT

INTRO

NEW YORK IS A BREEDING GROUND FOR FORWARD-THINKING, DARING CONCEPTS BECAUSE IT CONSISTENTLY DRAWS IN THE WORLD'S MOST CREATIVE MINDS—THOSE HIGHLY EXPERIMENTAL INDIVIDUALS WHO WANT TO BE INSPIRED FROM ALL THAT EXISTS IN THE CITY TODAY, AND WHO WILL MAKE THEIR MARK IN THE WORLD OF TOMORROW. IT DOESN'T HURT THAT NEW YORK CITY IS RICH IN CULTURE WITH ITS LITERAL MILE OF MUSEUMS AND HUNDREDS OF GALLERIES. CHEFS FLOCK HERE TO INVENT AND APPLY NEW DINING STYLES, MAKING IT THE RESTAURANT CAPITAL OF THE WORLD. IT IS ALSO THE PLACE WHERE THE NEWEST PRODUCTS AND AVANT-GARDE STYLES HIT THE SHELVES FIRST IN TRENDY HIGH-CONCEPT STORES AND ECLECTIC BOUTIQUES FEATURED IN THESE PAGES. IN ESSENCE, NEW YORK EMBODIES EVERYTHING WHAT ANY COOL CITY SHOULD ASPIRE TO BE: EXCITING, REBELLIOUS, NON-CONFORMING, WITH AN INSATIABLE DESIRE TO REINVENT ITSELF AND STAND APART.

DIE STADT NEW YORK GILT ALS NÄHRBO-
DEN FÜR VORDENKER UND WAGEMUTIGE
UND ZIEHT SEIT JEHER DIE KREATIVSTEN
KÖPFE IN IHREN BANN. EXPERIMENTIER-
FREUDIGE LASSEN SICH VON ALLEM,
WAS DIESE METROPOLE ZU BIETEN HAT,
INSPIRIEREN UND WERDEN SOMIT UNSERE
ZUKUNFT PRÄGEN. AUCH DAS REICHE
KULTURANGEBOT MIT MUSEUMSMEILE
UND HUNDERTEN VON KUNSTGALERIEN
IST ALLES ANDERE ALS EIN NACHTEIL.
DIE STADT GENIESST ZUDEM DEN RUF,
RESTAURANT-HAUPTSTADT DER WELT ZU
SEIN, DENN BERÜHMTE KÜCHENCHEFS
KOMMEN IN SCHAREN, UM NEUE GASTRO-
NOMISCHE STILE ZU KREIEREN UND ZU
PRÄSENTIEREN. DIE NEUESTEN PRODUKTE
SOWIE AVANTGARDISTISCHE TRENDS
LANDEN ZUALLERERST HIER IN DEN
REGALEN DER ANGESAGTEN BOUTIQUEN
UND LÄDEN, DIE IN DIESEM BAND
VORGESTELLT WERDEN. KURZUM, NEW
YORK IST DAS, WAS JEDE MODERNE UND
COOLE STADT SEIN MÖCHTE: AUFREGEND,
REBELLISCH, UNKONVENTIONELL UND
GETRAGEN VON DEM WUNSCH, SICH
SELBST IMMER WIEDER NEU ZU ERFINDEN
UND HERAUSZUSTECHEN.

INTRO

VÉRITABLE VIVIER DE CONCEPTS
AUDACIEUX ET AVANT-GARDISTES, NEW
YORK NE CESSE D'ATTIRER LES ESPRITS LES
PLUS CRÉATIFS DU MONDE. CES AVEN-
TURIERS DE L'EXPÉRIMENTAL COMPTENT
PROFITER DE TOUT CE QUE LA VILLE
PROPOSE AUJOURD'HUI ET S'EN SERVIR
POUR MARQUER DE LEUR EMPREINTE
LE MONDE DE DEMAIN. FORTE DE SA RI-
CHESSE CULTURELLE, LA VILLE PEUT ÉGA-
LEMENT SE VANTER DE SON MUSEUM MILE
OÙ SE CÔTOIENT MUSÉES ET CENTAINES
DE GALERIES. LES GRANDS CHEFS S'Y
RENDENT POUR REDÉFINIR L'ART DE
MANGER, CE QUI FAIT DE NEW YORK
LA CAPITALE MONDIALE DE LA GASTRO-
NOMIE. ELLE EST AUSSI LA VILLE OÙ LES
PRODUITS ET STYLES D'AVANT-GARDE LES
PLUS RÉCENTS DÉBARQUENT EN PREMIER
DANS LES BACS ET ÉTAGÈRES DE MAGA-
SINS TENDANCE AUX CONCEPTIONS
SPECTACULAIRES ET DANS LES BOUTIQUES
ÉCLECTIQUES DONT IL EST QUESTION
DANS LE PRÉSENT VOLUME. NEW YORK
INCARNE ESSENTIELLEMENT CE À QUOI
TOUTE VILLE BRANCHÉE DEVRAIT ASPI-
RER: PASSION, REBELLION, ANTICONFOR-
MISME AINSI QU'UN DÉSIR INSATIABLE DE
SE RÉINVENTER ET DE SE DÉMARQUER.

NUEVA YORK ES UN CALDO DE CULTIVO PARA LAS IDEAS MÁS PUNTERAS Y ATREVIDAS PORQUE ATRAE INCESANTEMENTE A LAS MENTES MÁS CREATIVAS, A AQUELLOS CON GANAS DE EXPERIMENTAR Y DISPUESTOS A DEJARSE INSPIRAR POR TODO LO QUE EXISTE HOY EN LA URBE, A AQUELLOS CAPACES DE DEJAR HUELLA EN EL FUTURO. NO VIENE MAL TAMPOCO QUE LA CIUDAD TENGA UNA ENORME OFERTA CULTURAL, ENTRE LA CUAL SE CUENTAN LITERALMENTE QUILÓMETROS ENTEROS DE MUSEOS Y CIENTOS DE GALERÍAS DE ARTE. EN NUEVA YORK, LA CAPITAL DE LA RESTAURACIÓN POR ANTONOMASIA, LOS GRANDES CHEFS SE DAN CITA PARA DESCUBRIR E INTRODUCIR NUEVOS ESTILOS GASTRONÓMICOS. AQUÍ, LOS PRODUCTOS MÁS NUEVOS Y LOS ESTILOS MÁS VANGUARDISTAS LLENAN ANTES QUE EN NINGÚN OTRO LUGAR LAS ESTANTERÍAS DE LAS MODERNÍSIMAS TIENDAS Y ECLÉCTICAS BOUTIQUES QUE SE PRESENTAN EN ESTAS PÁGINAS. EN RESUMEN, NUEVA YORK REPRESENTA TODO LO QUE UNA CIUDAD MODERNA, ATRACTIVA Y DESENFRENADA DEBERÍA TENER: ES APASIONANTE, REBELDE Y ROMPE MOLDES CON SUS GANAS IRREFRENABLES DE REINVENTARSE Y DESTACAR.

HOTELS

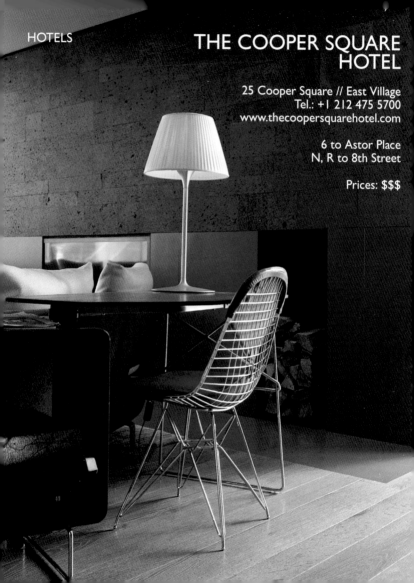

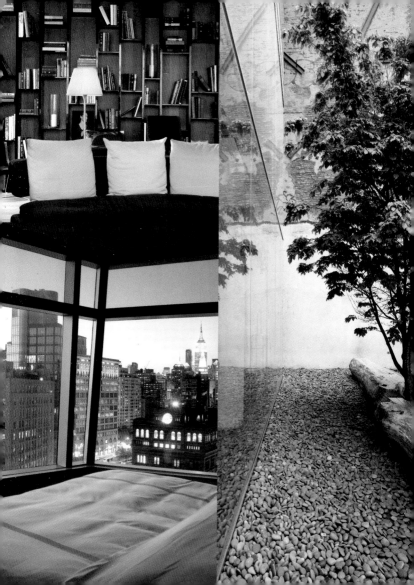

The glass tower in the East Village defies more than architectural conventions. Rather than checking in at the reception desk, guests are led into the library, where they can make themselves comfortable, browse newspapers and books, and have a drink. Literature also adds to the hotel's character in other ways: more than 4,000 used books are available for sale in the building. Proceeds are donated to charity organizations.

Nicht nur architektonisch trotzt der gläserne Turm im East Village Konventionen. Statt an der Rezeption einzuchecken, werden Gäste in die Bibliothek geleitet, wo sie es sich gemütlich machen, in Zeitungen und Büchern blättern und einen Drink zu sich nehmen können. Literatur trägt auch sonst zum Charakter des Hotels bei: Mehr als 4 000 antiquarische Bücher liegen zum Verkauf im Haus aus. Die Erlöse werden wohltätigen Sozialprogrammen gestiftet.

Cette tour de verre, située dans East Village, défie les conventions architectoniques et bien d'autres encore. Au lieu de se faire enregistrer à la réception, les clients sont orientés vers la bibliothèque, où ils peuvent s'installer confortablement, feuilleter journaux et livres et prendre un verre. La littérature contribue également au caractère atypique de l'hôtel ; plus de 4 000 livres d'occasion y sont à vendre. Le produit des ventes est reversé à des associations de bienfaisance.

No sólo la arquitectura de la torre de cristal en el East Village se resiste a las convenciones. En lugar de registrarse en la recepción, los huéspedes son conducidos a la biblioteca, donde pueden ponerse cómodos, hojear periódicos y libros y beber algo. La literatura influye también de otra forma en el carácter del hotel: en la casa hay más de 4 000 libros usados a la venta. Las ganancias se donan a programas sociales benéficos.

LAFAYETTE HOUSE

38 E 4th Street // East Village
Tel.: +1 212 505 8100
www.lafayettenyc.com

6 to Astor Place
N, R to 8th Street

Prices: $$$

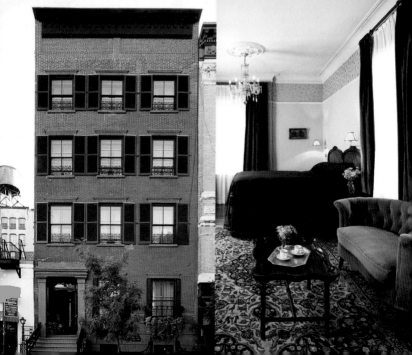

The restored four-story 19th-century townhouse has neither a bustling lobby nor a reception desk. Guests ring the doorbell and are received by the staff and led to their rooms as if they were in a private home. All 15 spacious rooms with antique furnishings are equipped with fireplace and kitchenette. A private garden awaits in back.

In dem restaurierten, vierstöckigen Stadthaus aus dem 19. Jahrhundert gibt es weder eine geschäftige Lobby noch eine Rezeption. Gäste klingeln am Eingang, werden vom Personal empfangen und auf ihre Zimmer geführt, ganz so als wären sie zu Gast in einem Privatquartier. Alle 15 geräumigen, individuell mit Antiquitäten eingerichteten Zimmer sind mit einem Kamin und Küchenzeile ausgestattet. Hinter dem Haus befindet sich noch ein privater Garten.

Cet immeuble rénové à quatre étages, datant du XIXe siècle, ne comprend pas de hall agité ni de réception. Les clients sonnent à l'entrée et sont accueillis et dirigés vers leur chambre par le personnel comme s'ils étaient invités dans des logements privés. Les 15 chambres spacieuses, personnalisées et meublées d'antiquités, sont dotées d'une cheminée et d'une cuisine linéaire. Derrière l'immeuble, un jardin privé vous attend.

En el restaurado edificio de cuatro pisos del siglo XIX no hay ni lobby ni recepción. Los huéspedes tocan el timbre en la entrada y son recibidos por el personal y conducidos a sus habitaciones, como si estuvieran en una casa de habitaciones en alquiler. Cada una de las 15 cómodas estancias, decoradas individualmente con antigüedades, poseen chimenea y cocina. Detrás de la casa aguarda un jardín privado.

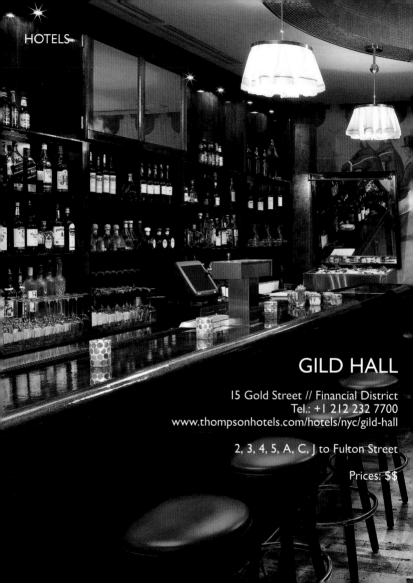

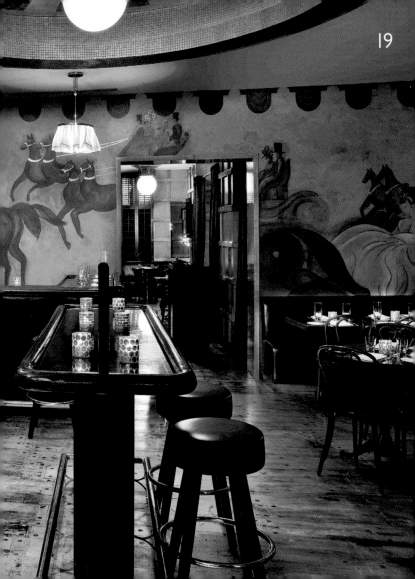

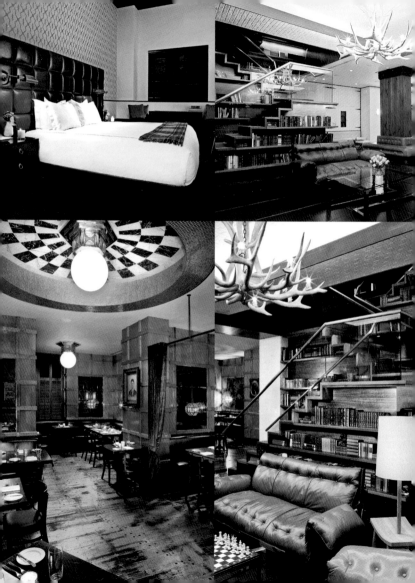

In the heart of the Financial District, just a few blocks from Wall Street, this building on historic Gold Street opened in 2008. Far from Midtown's tourist throngs, the lobby spanning two floors transports you to the world of a private British club with its dark leather sofas, animal skin rugs, and a modern version of a deer antler chandelier. The library and bar on the third floor invite you to spend a while there.

Im Herzen des Finanzdistrikts, nur wenige Blocks von der Wall Street entfernt, eröffnete 2008 das Haus in der historischen Gold Street. Fernab des Touristenrummels in Midtown entführt die Lobby, die sich über zwei Etagen erstreckt, mit ihren dunklen Ledersofas, Tierfellteppichen und einer modernen Version eines Hirschgeweihlüsters in die Welt eines britischen Privatklubs. Die Bibliothek und Bar im zweiten Stock laden zum Verweilen ein.

En plein cœur du quartier de la finance, à quelques blocks de Wall Street, cet hôtel a ouvert ses portes en 2008 dans l'historique Gold Street. À l'écart du flot de touristes du quartier de Midtown, le hall, qui s'étend sur deux étages et présente de beaux canapés en cuir, des tapis en peaux de bêtes et une version revisitée du lustre ramure de cerf, vous emmène dans l'univers d'un club privé britannique. La bibliothèque et le bar, situés au deuxième étage, invitent à la détente.

En 2008 abrió sus puertas esta casa en la histórica Gold Street, en pleno corazón del distrito financiero y a pocas manzanas de Wall Street. Lejos del ajetreo de los turistas en Midtown, su vestíbulo repartido por dos pisos con sofás de cuero oscuro, alfombras de piel y una moderna versión de una araña con astas de ciervo transporta al mundo de un club privado británico. La biblioteca y el bar de la segunda planta invitan a quedarse.

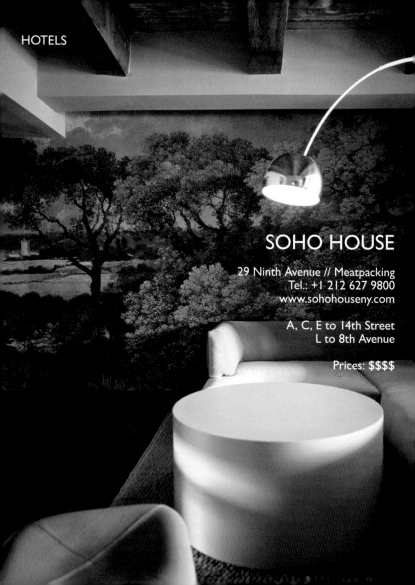

SOHO HOUSE

29 Ninth Avenue // Meatpacking
Tel.: +1 212 627 9800
www.sohohouseny.com

A, C, E to 14th Street
L to 8th Avenue

Prices: $$$$

Membership in the exclusive private club in the Meatpacking District grants entry to one of Manhattan's most coveted meeting points: the pool and lounge area on the roof, where celebrities are encountered and hot parties celebrated. Hotel guests can also make use of the pool deck and other amenities such as fitness studio, spa, and screening room. They do, however, pay more than members for club privileges.

Die Mitgliedschaft in dem exklusiven Privatclub im Meatpacking District gewährt Zutritt zu einem der begehrtesten Treffpunkte Manhattans: dem Pool samt Lounge Area auf dem Dach, wo Prominenz verkehrt und heiße Partys gefeiert werden. Auch Hotelgäste können die Poolterrasse und weitere Annehmlichkeiten wie Fitness Studio, Spa und hauseigenes Kino in Anspruch nehmen. Sie zahlen für die Clubprivilegien jedoch mehr als die Mitglieder.

VALESCA GUERRAND HERMES'S SPECIAL TIP

One of the few places in NYC where you can put on a bathing suit and enjoy the roof deck pool. It can be quite a scene...

Une adhésion au club privé exclusif du Meatpacking District permet d'accéder à l'un des endroits les plus prisés de Manhattan, ainsi qu'à sa piscine et son espace lounge sur le toit, où les stars se retrouvent pour des soirées endiablées. Les clients de l'hôtel peuvent aussi profiter de la piscine sur le toit-terrasse et autres équipements de premier choix comme la salle de fitness, le spa et le cinéma. Pour profiter de tels privilèges, ces derniers devront toutefois payer plus que les membres du club.

La pertenencia al exclusivo club privado en el Meatpacking District permite la entrada a uno de los puntos de encuentro más populares de Manhattan: el área compuesta por piscina y salón en la azotea, frecuentada por las celebridades y donde se celebran fiestas muy calientes. Los huéspedes del hotel también pueden disfrutar de la piscina y de otras comodidades como el gimnasio, el spa y el cine privados. Sin embargo, deben pagar más que los miembros del club por estos privilegios.

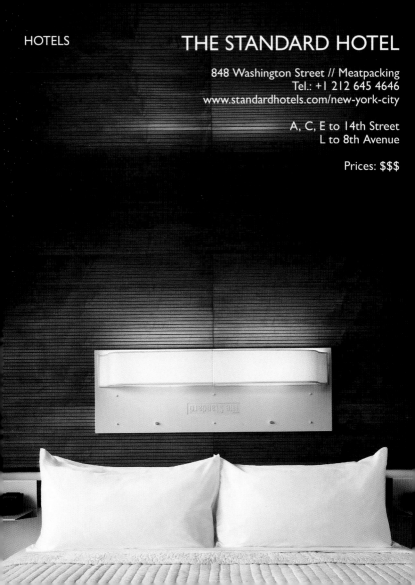

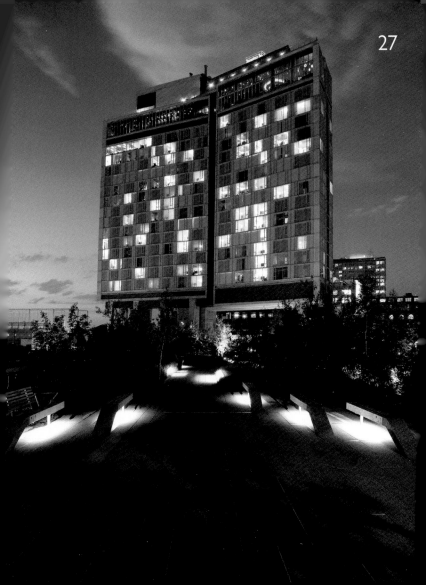

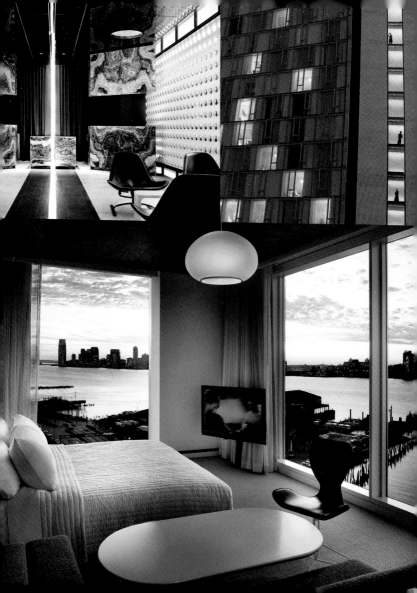

Built on columns, the 20-story tower rises above the High Line Park, a green oasis installed on decommissioned elevated train tracks. The architecture of hotelier André Balazs's newest attraction allows breathtaking vistas of the Hudson River and Midtown, whether from the bed or the doorless bathroom. In return, the panoramic windows give passers-by an interesting glimpse of the hotel's inner life.

Auf Säulen erbaut, ragt der 20-stöckige Turm über den High Line Park, eine grüne Oase, die auf stillgelegten, erhöhten Bahngleisen angelegt wurde. Die Architektur der neuesten Attraktion von Hotelier André Balazs erlaubt atemberaubende Aussichten auf den Hudson und Midtown, ob vom Bett oder dem türlosen Badezimmer aus. Im Gegenzug gewähren die Fensterfronten den Passanten einen interessanten Einblick in das Innenleben des Hotels.

VALESCA GUERRAND
HERMES'S SPECIAL TIP

Uptown meets
downtown...
good people-watching.
.

Construite sur des piliers, cette tour de 20 étages surplombe le High Line Park, une oasis de verdure aménagée sur d'anciennes voies ferrées aériennes désaffectées. L'architecture du dernier né de la galaxie André Balazs offre des vues extraordinaires sur la rivière Hudson et Midtown, que l'on soit dans son lit ou en train de faire ses ablutions dans la salle de bain ouverte. Par contre, les baies vitrées n'empêchent pas les passants de contempler ce qui se passe à l'intérieur.

Construída sobre pilares, la torre de 20 pisos se eleva por encima del parque High Lane, un oasis verde cultivado sobre antiguas vías de metro elevadas. La arquitectura de la nueva atracción del hotelero André Balazs permite disfrutar de vistas espectaculares del Hudson y del Midtown, ya sea desde la cama o desde el baño sin puertas. A cambio, las fachadas de vidrio ofrecen a los transeúntes una interesante mirada a la vida interior del hotel.

ACE HOTEL

20 W 29th Street // NoMad
Tel.: +1 212 679 2222
www.acehotel.com

N, R to 28th Street

Prices: $$

FLOWERS

The first New York offshoot of Seattle's hotel chain for trendsetters opened in 2009 in a historic building in the up-and-coming NoMad neighborhood (North of Madison Square Park). Numerous historical details were preserved during the renovation. Exposed columns and the original tile floor mosaic grace the lobby, which functions as a bar with a live DJ in the afternoon and quickly advanced to the status of meeting point for the hip crowd.

Der erste New Yorker Ableger der in Seattle ansässigen Hotelkette für Trendsetter eröffnete 2009 in einem histori- schen Gebäude im „up and coming" Viertel NoMad (North of Madison Square Park). Bei der Renovierung wurden viele historische Details erhalten. Freigelegte Säulen und der Boden mit ursprünglichem Kachelmosaik zieren die Hotellobby, die nachmittags als Bar mit Live-DJ fungiert und schnell zum Treff- punkt der Szenekenner avancierte.

Le premier New-yorkais de cette chaîne d'hôtels basée à Seattle, destinée aux faiseurs de tendances, a ouvert ses portes en 2009, dans un immeuble historique du quartier montant de NoMad (North of Madison Square Park). Lors de la rénovation, de nombreux détails historiques ont été préservés. Les colonnes qui ont été dégagées et le sol en carreaux de mosaïques d'origine rehaussent le hall de l'hôtel, qui se transforme l'après-midi en bar avec DJ et point de rencontre de la scène branchée.

La única sucursal en Nueva York de la cadena de hoteles para creadores de tendencias abrió en 2009 en un edi- ficio histórico del barrio de NoMad (North of Madison Square Park). Durante la renovación se conservaron mu- chos detalles históricos. El vestíbulo del hotel, adornado con columnas originales recuperadas de los escombros y un mosaico de baldosines, se transforma por las tardes en un bar con DJ en vivo, punto de encuentro habitual de los entendidos de la escena.

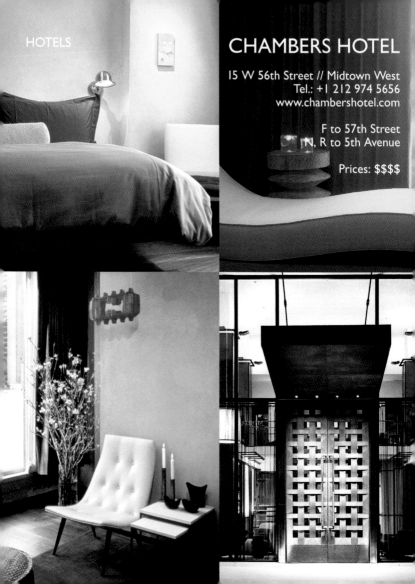

CHAMBERS HOTEL

15 W 56th Street // Midtown West
Tel.: +1 212 974 5656
www.chambershotel.com

F to 57th Street
N, R to 5th Avenue

Prices: $$$$

Glass elevators convey guests to their spacious rooms designed with high ceilings, large panoramic windows, and rough concrete walls inspired by SoHo artist lofts. Walls are adorned with works of art specially created for the hotel. Fitting the hotel's location in the middle of Fifth Avenue shopping mecca, guests need only press a button to schedule an appointment with a personal shopper at the exclusive department store Henri Bendel.

Gläserne Fahrstühle geleiten Gäste zu ihren großzügig geschnittenen Räumen, die mit hohen Decken, großen Fensterfronten und rohen Betonwänden in Anlehnung an Künstlerlofts in SoHo gestaltet wurden. Die Wände schmücken eigens für das Hotel entworfene Kunstwerke. Der Lage inmitten des Shopping-Mekkas an der Fifth Avenue angemessen, können Hotelgäste per Tastendruck einen Termin mit einem Personal Shopper im Edelkaufhaus Henri Bendel vereinbaren.

Des ascenseurs de verre escortent les clients jusqu'à leurs chambres, de généreux espaces avec belle hauteur sous plafond, de grandes baies vitrées et des murs en béton brut rappelant les lofts d'artistes de SoHo. Les murs sont de véritables œuvres d'art créés spécialement pour l'hôtel. Vu que celui-ci est situé au cœur de la Mecque du shopping, à côté de la 5e avenue, rien de plus simple pour les clients que de fixer un rendez-vous à un « personal shopper » dans le sublime grand magasin Henri Bendel.

Ascensores de cristal llevan a los huéspedes a sus amplias habitaciones de techos altos, fachadas de vidrio y paredes de hormigón en bruto, que imitan los lofts de los artistas en el SoHo. Las paredes están decoradas con obras de arte creadas especialmente para el hotel. Acorde con su situación en medio de la Meca de las compras de la Quinta Avenida, los huéspedes del hotel pueden, apretando un botón, concertar una cita con su "personal shopper" en el centro comercial de lujo Henri Bendel.

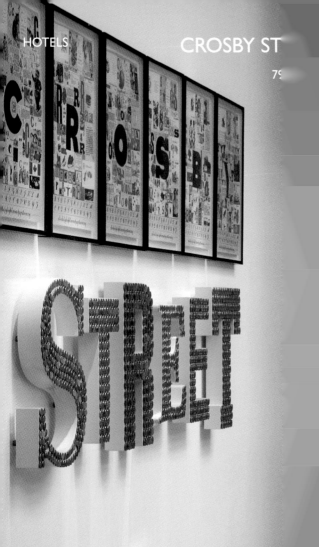

The British design team of Tim and Kit Kemp created an eco-conscious construction of brick, steel, and glass on the site of a former parking lot in SoHo. The design of the lobby with its bold colors and non-minimalistic decor produces an appealing contrast to the neighborhood's industrial flair. Blueberries and tomatoes grow in the rooftop garden. The four chickens also in residence provide fresh eggs for breakfast.

Auf dem Gelände eines ehemaligen Parkplatzes in SoHo schufen das britische Designerteam Tim und Kit Kemp eine öko-bewusste Konstruktion aus Ziegelstein, Stahl und Glas. Das Design der Lobby mit ihren kräftigen Farben und non-minimalistischem Dekor bildet einen reizvollen Kontrast zum Industrieflair des Viertels. Auf dem Dachgarten wachsen Blaubeeren und Tomaten. Die vier dort ebenfalls heimischen Hühner liefern frische Frühstückseier.

Sur un ancien parking du quartier de SoHo, les designers britanniques Tim et Kit Kemp ont réalisé une construction respectueuse de l'environnement, constituée de briques, d'acier et de verre. Le hall de l'hôtel, qui arbore des coloris soutenus et un décor peu minimaliste, offre un contraste fascinant au caractère industriel du quartier. Des myrtilles et tomates poussent dans le jardin sur le toit. Les œufs du petit-déjeuner proviennent des quatre poules qui vivent sur ce toit-terrasse.

Sobre los terrenos de un antiguo aparcamiento en el SoHo, el equipo de diseñadores británico Tim y Kit Kemp creó una construcción ecológica de ladrillo, acero y cristal. El diseño del vestíbulo, con sus intensos colores y su decoración nada minimalista, constituye un encantador contraste con el ambiente industrial del barrio. En la cubierta ajardinada crecen arándanos y tomates. Los huevos frescos para el desayuno son proporcionados por las cuatro gallinas que también habitan el lugar.

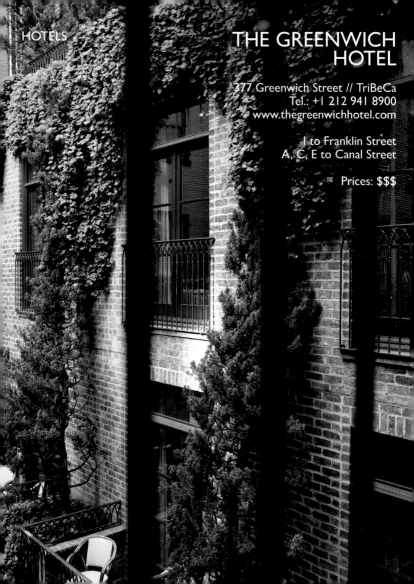

THE GREENWICH HOTEL

377 Greenwich Street // TriBeCa
Tel.: +1 212 941 8900
www.thegreenwichhotel.com

1 to Franklin Street
A, C, E to Canal Street

Prices: $$$

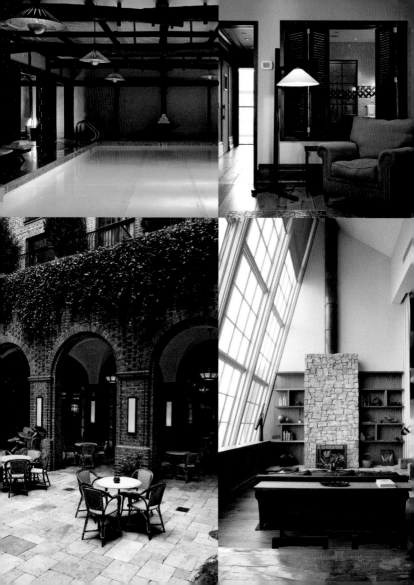

Not one of the 88 rooms is like another. The decor offers a fascinating mixture of cultural influences from all over the world. Accessible only to hotel guests, the lobby with its interior courtyard is an oasis of calm in the middle of TriBeCa. The relaxing atmosphere is completed with the hotel's own Shibui Spa: the pool is surrounded by elements of a 250-year-old wood and bamboo farmhouse reconstructed by Japanese workmen.

Keiner der 88 Räume gleicht dem anderen. Das Dekor bietet eine faszinierende Mischung kultureller Einflüsse aus aller Welt. Die nur für Hotelgäste zugängliche Lobby ist mit ihrem Innenhof eine Oase der Ruhe mitten in TriBeCa. Abgerundet wird die entspannende Atmosphäre durch das hauseigene Shibui Spa: Der Pool befindet sich in einem 250 Jahre alten Bauernhaus aus Holz und Bambus, das japanische Handwerker rekonstruiert haben.

Les 88 chambres dévoilent chacune leur propre personnalité. Le décor offre une association fascinante d'influences du monde entier. Le hall, accessible uniquement aux clients et doté d'une cour intérieure, est un sublime havre de paix au cœur de TriBeCa. Pour une atmosphère encore plus relaxante, l'hôtel offre son propre Shibui Spa. Autour de la piscine, vous pouvez admirer une ferme japonaise en bois et bambou vieille de 250 ans, reconstruite par des artisans japonais.

Cada una de las 88 habitaciones es única. La decoración ofrece una fascinante mezcla de influencias culturales de todo el mundo. El vestíbulo, sólo accesible para los huéspedes del hotel, es con su patio interior un oasis de tranquilidad en pleno centro del barrio TriBeCa. La relajante atmósfera se completa con el Shibui Spa privado: la piscina está rodeada por elementos de madera y bambú tomados de una casa de labranza de 250 años de edad, reconstruída por artesanos japoneses.

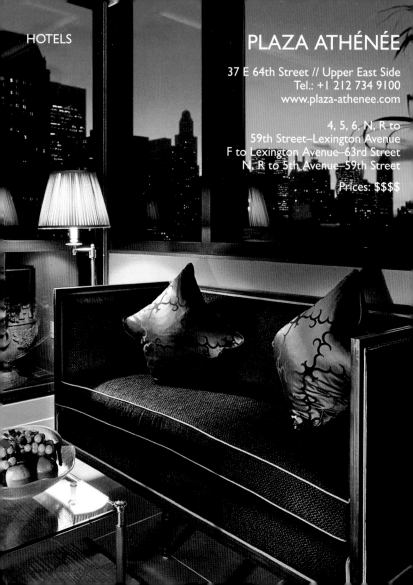

PLAZA ATHÉNÉE

37 E 64th Street // Upper East Side
Tel.: +1 212 734 9100
www.plaza-athenee.com

4, 5, 6, N, R to
59th Street–Lexington Avenue
F to Lexington Avenue–63rd Street
N, R to 5th Avenue–59th Street

Prices: $$$$

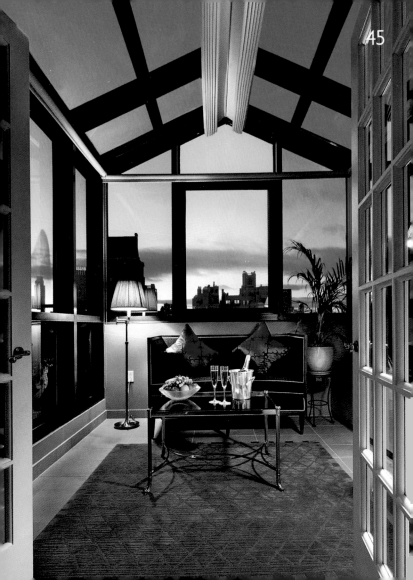

Located on a quiet side street on the Upper East Side, the luxurious boutique hotel is known for its hospitality and personal service. Guests include many regulars for whom Plaza Athénée is a home away from home. The glassed-in balconies of the suites offer a spectacular view of the skyline, and at Arabelle guests enjoy one of the city's best restaurants.

In einer ruhigen Nebenstraße auf der Upper East Side befindet sich das luxuriöse Boutiquehotel, das für seine Gastlichkeit und seinen persönlichen Service berühmt ist. Unter den Besuchern gibt es viele Stammgäste, für die das Plaza Athénée ein zweites Zuhause ist. Von den verglasten Terrassen der Suiten bietet sich ein einmaliger Blick auf die Skyline, und mit dem Arabelle kommen die Gäste in den Genuss eines der besten Restaurants der Stadt.

Cet hôtel-boutique de luxe, réputé pour son hospitalité et son service personnalisé, se situe dans une rue secondaire paisible de l'Upper East Side. Ses clients comptent de nombreux habitués pour qui le Plaza Athénée est une seconde maison. La terrasse vitrée des suites offre une vue unique sur la skyline et l'Arabelle propose aux clients le raffinement et la délectation de l'un des meilleurs restaurants de la ville.

En una tranquila calle lateral en el Upper East Side se encuentra el lujoso hotel boutique, famoso por su hospitalidad y su servicio personal. Entre los visitantes hay muchos clientes habituales para los que el Plaza Athénée es una segunda casa. Desde las terrazas acristaladas de las suites se presenta una vista única del panorama urbano y los huéspedes disfrutan en Arabelle de uno de los mejores restaurantes de la ciudad.

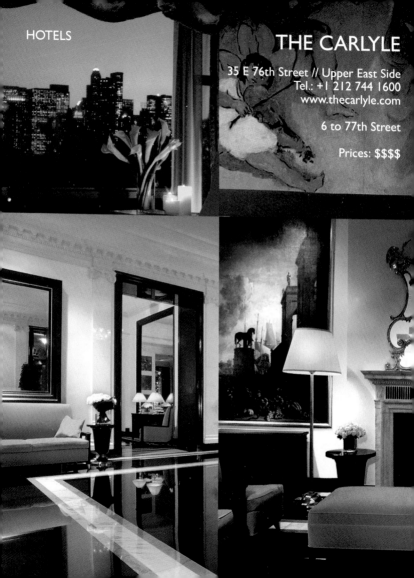

THE CARLYLE

35 E 76th Street // Upper East Side
Tel.: +1 212 744 1600
www.thecarlyle.com

6 to 77th Street

Prices: $$$$

Time seems to stand still in the dignified Upper East Side building not far from Central Park, the preferred residence of leading personalities in politics, industry, and culture since its opening in 1930. Though the city might otherwise rapidly change and constantly renew itself, this landmark possesses the aura of days gone by. Attentive service from the golden age of luxury hotels is emphasized here.

In dem ehrwürdigen Haus auf der Upper East Side unweit des Central Parks, das seit seiner Eröffnung 1930 bevorzugtes Domizil für führende Persönlichkeiten aus Politik, Wirtschaft und Kultur ist, scheint die Zeit stillzustehen. Mag sich die Stadt sonst rasant verändern und stets erneuern, dieses Wahrzeichen der Stadt vermittelt die Aura vergangener Tage. Anspruchsvoller Service aus den goldenen Zeiten der Luxushotels wird hier groß geschrieben.

VALESCA GUERRAND HERMES'S SPECIAL TIP

Uptown elegance.

Ce vénérable hôtel, situé dans le quartier de l'Upper East Side à deux pas de Central Park, lieu de prédilection des personnalités influentes de la politique, de l'économie et la culture depuis son ouverture en 1930, ne s'est pas figé dans le temps. Même si la ville évolue à toute allure et n'a de cesse de se renouveler, cet emblème continue de véhiculer l'aura du passé. Ici, le service prestigieux est issu de l'âge d'or des hôtels de luxe.

En la respetable casa en el Upper East Side no lejos de Central Park, desde su apertura en 1930 domicilio preferido por los líderes de la política, la economía y la cultura, el tiempo parece detenido. Aunque la ciudad cambie a un ritmo vertiginoso y se renueve continuamente, este monumento de la ciudad transmite el aura de días pasados. El exigente servicio de la edad de oro de los hoteles de lujo tiene aquí una gran importancia.

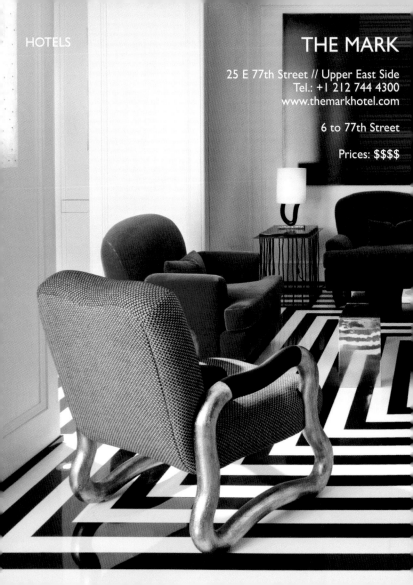

THE MARK

25 E 77th Street // Upper East Side
Tel.: +1 212 744 4300
www.themarkhotel.com

6 to 77th Street

Prices: $$$$

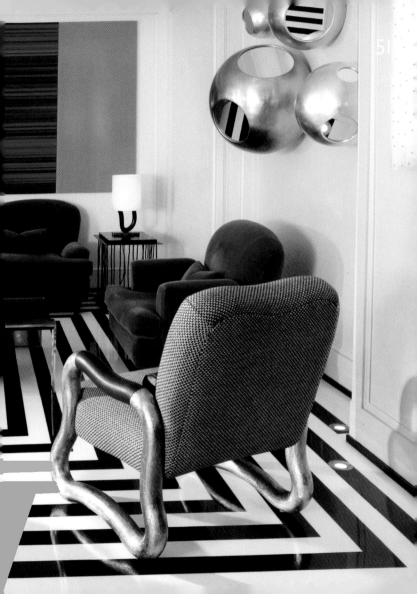

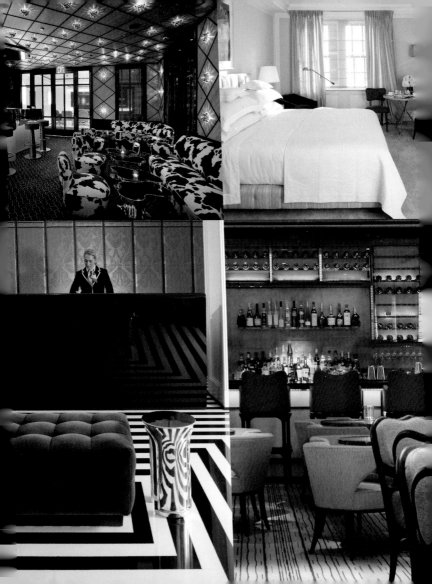

With its timeless elegance, the history-laden building on the Upper East Side is proof that tradition does not have to be old-fashioned. Using bold geometric patterns and forms, Jacques Grange has given the hotel a hint of downtown. TV monitors built into bathroom mirrors are one example of the ultramodern amenities. First-class hospitality includes 24/7 room service by star chef Jean-Georges Vongerichten.

Mit seiner zeitlosen Eleganz stellt das geschichtsträchtige Haus auf der Upper East Side unter Beweis, dass Tradition nicht altmodisch sein muss. Mithilfe kühner geometrischer Muster und Formen verlieh Jacques Grange dem Hotel einen Hauch von Downtown. In Badezimmerspiegel eingebaute TV-Monitore sind ein Beispiel der hochmodernen Zimmerausstattung. Zur erstklassigen Gästebetreuung gehört Rund-um-die-Uhr-Roomservice von Starkoch Jean-Georges Vongerichten.

VALESCA GUERRAND HERMES'S SPECIAL TIP

A perfect place for a quiet drink.

L'élégance intemporelle de cet hôtel chargé d'histoire, situé dans l'Upper East Side, prouve bien que tradition ne rime pas forcément avec désuétude. À l'aide de formes et motifs géométriques et audacieux, Jacques Grange a donné à cet hôtel un air de Downtown. Des écrans TV sont encastrés dans les miroirs de salle de bain ; l'équipement des chambres se veut ultramoderne. Le service en chambre 24h/24 et 7j/7 qui propose la cuisine du chef multi étoilé, Jean-Georges Vongerichten, est de première classe.

Con su elegancia atemporal, la histórica casa en el Upper East Side demuestra que la tradición no tiene que estar pasada de moda. Con ayuda de atrevidas figuras y formas geométricas, Jacques Grange dio al hotel una pizca de Downtown. Los monitores de televisión incorporados en los espejos del baño son un ejemplo del moderno equipamiento. El servicio de habitaciones 24 horas del famoso chef Jean-Georges Vongerichten forma parte de la atención de primera de la que disfrutan los huéspedes.

RESTAURANTS
+CAFÉS

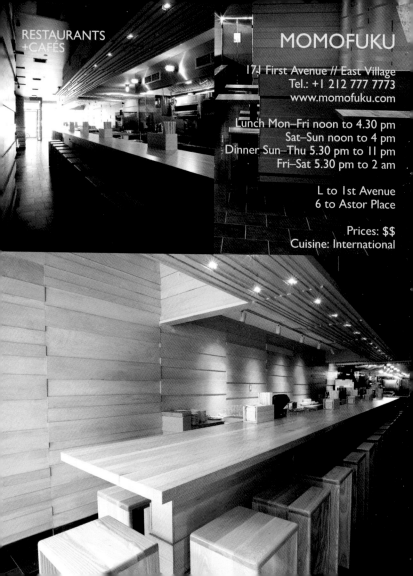

MOMOFUKU

171 First Avenue // East Village
Tel.: +1 212 777 7773
www.momofuku.com

Lunch Mon–Fri noon to 4.30 pm
Sat–Sun noon to 4 pm
Dinner Sun–Thu 5.30 pm to 11 pm
Fri–Sat 5.30 pm to 2 am

L to 1st Avenue
6 to Astor Place

Prices: $$
Cuisine: International

Sitting on high stools at long counters, lovers of the Japanese national dish ramen slurp their soup and noodles in innovative variations with ingredients like poached eggs or pickled pears at the popular meeting place in the East Village. But the noodle soup eatery named for the inventor of the traditional dish is even more famous for its steamed pork buns: pork with sliced pickles and sauce in a fluffy pancake.

An langen Theken und auf hohen Barstühlen sitzend, schlürfen Liebhaber des japanischen Nationalgerichts Ramen im In-Treff im East Village die Nudeln und Suppen in innovativen Varianten mit Zutaten wie pochierten Eiern oder eingelegten Birnen. Noch berühmter ist die nach dem Erfinder der Traditions-speise benannte Nudelsuppenküche jedoch für seine Steamed Pork Buns: Schweinefleisch mit Gurkenscheiben und Soße in einem luftigen Pfannkuchen.

Dans le quartier en vogue d'East Village, sur de hauts tabourets de bar accolés à de longs comptoirs, les amateurs de ramen, le plat national japonais, dégustent des nouilles et soupes revisitées audacieusement avec des ingrédients tels que des œufs pochés ou poires confites. Cependant, cet établissement, du nom de l'inventeur du plat traditionnel de soupes de nouilles, est encore plus renommé pour ses « steamed pork buns » : porc, rondelles de concombre et sauce, le tout enroulé dans une crêpe légère.

En el local de moda del East Village, sentados sobre altos bancos frente a largas barras, los amantes del ramen, el plato nacional japonés, sorben los tallarines y las sopas en innovadoras variantes con ingredientes como huevos escalfados o peras marinadas. Sin embargo, la cocina de sopas de tallarines bautizada con el nombre del inventor del plato tradicional, es más famosa por sus "steamed pork buns": carne de cerdo con rodajas de pepino y salsa en una esponjosa tortita.

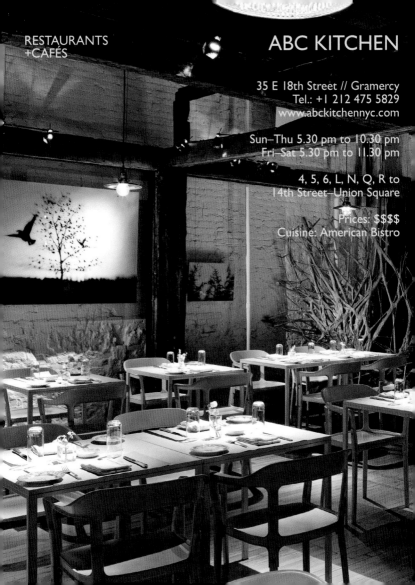

RESTAURANTS
+CAFÉS

ABC KITCHEN

35 E 18th Street // Gramercy
Tel.: +1 212 475 5829
www.abckitchennyc.com

Sun–Thu 5.30 pm to 10.30 pm
Fri–Sat 5.30 pm to 11.30 pm

4, 5, 6, L, N, Q, R to
14th Street–Union Square

Prices: $$$$
Cuisine: American Bistro

Environmental sustainability is writ large at Jean-Georges Vongerichten's restaurant in the home furnishings center ABC Carpet & Home. Ingredients come from certified organic farms in the region. Menus are printed on recycled paper, tablecloths are reusable, and all leftovers end up in the compost instead of the trash. Herbs and greens are harvested from the rooftop garden and the breadbaskets are produced by a Patagonian Indian tribe.

In Jean-Georges Vongerichtens Restaurant im Einrichtungskaufhaus ABC Carpet & Home wird Umweltverträglichkeit groß geschrieben. Die Zutaten kommen aus regionalem, biologisch-kontrolliertem Anbau. Speisekarten sind auf Altpapier gedruckt, Tischdecken wiederverwertbar, und statt im Mülleimer enden alle Essensreste auf dem Kompost. Kräuter und Suppengrün werden auf der Dachterrasse geerntet, und ein patagonischer Indianerstamm fertigte die Brotkörbe.

Dans le restaurant de Jean-Georges Vongerichten situé dans le grand magasin de décoration ABC Carpet & Home, le respect de l'environnement occupe une place centrale. Les produits utilisés proviennent d'une agriculture biologique régionale contrôlée. Les cartes sont imprimées sur du papier recyclé, les nappes sont recyclables et tous les restes partent au compost et non à la poubelle. Les herbes et la mirepoix poussent sur le toitterrasse et les corbeilles à pain furent confectionnées par une tribu d'Indiens de Patagonie.

En el restaurante de Jean-Georges Vongerichten en los grandes almacenes del hogar ABC Carpet & Home, el respeto por el medio ambiente juega un papel muy importante. Los ingredientes provienen de cultivos regionales controlados biológicamente. Las cartas son de papel reciclado, los manteles reutilizables y los restos de comida no terminan en la basura, sino como abono. Hierbas y verduras para sopas se cosechan en el jardín de la azotea y una tribu de indios de la Patagonia confeccionó las cestas del pan.

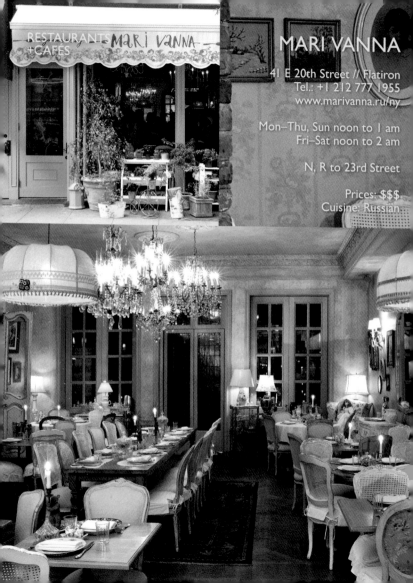

MARI VANNA

41 E 20th Street // Flatiron
Tel.: +1 212 777 1955
www.marivanna.ru/ny

Mon–Thu, Sun noon to 1 am
Fri–Sat noon to 2 am

N, R to 23rd Street

Prices: $$$
Cuisine: Russian

The name as motto: Mari Vanna, a figure from Russian folklore, took in strangers and offered princely hospitality. Among Russian antiques, you quickly feel as if you were in the home of friends when in this restaurant. It's not uncommon for other guests or the staff to join your table after the second or third round of vodka. Next to such Russian specialties as blinis and smoked fish, the menu boasts more than 20 kinds of vodka.

Der Name als Motto: Mari Vanna, eine Figur aus der russischen Folklore, nahm Fremde bei sich auf und bewirtete sie fürstlich. Zwischen russischen Antiquitäten fühlt man sich in diesem Restaurant schnell, als wäre man zu Hause bei Freunden. Nicht selten gesellen sich nach der zweiten oder dritten Runde Wodka andere Gäste oder das Personal zu einem dazu. Die Karte umfasst neben russischen Spezialitäten wie Blinis und Räucherfisch mehr als 20 Wodkasorten.

Ce nom est la devise du restaurant : Mari Vanna, figure du folklore russe, avait reçu des étrangers et les avait accueillis comme des rois. Entre les antiquités russes, on se sent rapidement comme chez des amis. Après la deuxième ou troisième tournée de vodka, il n'est pas rare que des clients sympathisent avec d'autres clients ou avec le personnel. La carte affiche des spécialités russes comme les blinis mais aussi du poisson fumé et plus de 20 sortes de vodkas.

El nombre como lema: Mari Vanna, una figura del folclore ruso, acogía a extraños en su casa y los trataba como a reyes. Entre antigüedades rusas, en este restaurante uno se siente rápidamente como si estuviera en casa de unos amigos. A menudo, otros comensales o el personal se unen a la propia mesa tras la segunda o tercera ronda de vodka. La carta contiene, junto a especialidades típicas rusas como blinis o pescado ahumado, más de 20 clases de vodka.

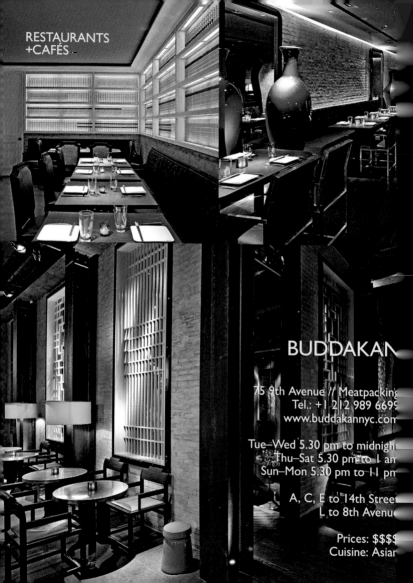

BUDDAKAN

75 9th Avenue // Meatpacking
Tel.: +1 212 989 6699
www.buddakannyc.com

Tue–Wed 5.30 pm to midnight
Thu–Sat 5.30 pm to 1 am
Sun–Mon 5.30 pm to 11 pm

A, C, E to 14th Street
L to 8th Avenue

Prices: $$$$
Cuisine: Asian

Buddakan is a veritable temple to Asian cuisine, located in the trendy Meatpacking District. Everything is gigantic here: chandeliers hang from the high ceilings, statues of Buddha and ancient pottery are exhibited. Music pumps through the speakers and creates a nightclub vibe. Asian-inspired cocktails infused with lychee or ginger are poured and the wine list offers an upscale sake selection. The entrees include lobster with black beans as well as sweet and sour crispy pork.

Das Buddakan ist ein wahrer Tempel für asiatische Küche im angesagten Meatpacking District. Kronleuchter hängen von der hohen Decke, Buddha-Statuen schmücken den Raum, die Musik verbreitet Club-Atmosphäre. Serviert werden asiatisch inspirierte Cocktails, z. B. mit Lychee oder Ingwer. Auf der Karte stehen Hummer mit schwarzen Bohnen oder geröstetes Schwein süß-sauer, dazu eine große Auswahl an Dim Sum und Reis-gerichten. Die Weinkarte bietet zudem erlesenen Sake aus Japan.

Le Buddakan est un véritable temple de la cuisine asiatique situé dans le quartier en vogue Meatpacking District. Les lustres accrochés au plafond haut, les statues de Bouddha parsemées dans toute la pièce et la musique d'ambiance garantissent une atmosphère de club lounge. Les cocktails servis s'inspirent des faveurs asiatiques, comme le lychee ou le gingembre. Homard aux haricots noirs, porc grillé aigre-doux et un grand choix de Dim Sum et de plats à base de riz sont proposés à la carte. La carte des vins propose un saké de premier choix du Japon.

Ubicado en el rejuvenecido Meatpacking District, el Buddakan es un verdadero templo de la cocina asiática. Lámparas de araña que cuelgan de techos altos, estatuas de Buda y objetos de cerámica antiguos; todo ello envuelto en una vibrante música que crea una atmósfera de club nocturno. Se sirven cócteles de inspiración asiática con lichi o jengibre y la carta de vinos ofrece una cuidada selección de sakes. Los entrantes van desde el bogavante con alubias negras hasta el cerdo en salsa agridulce.

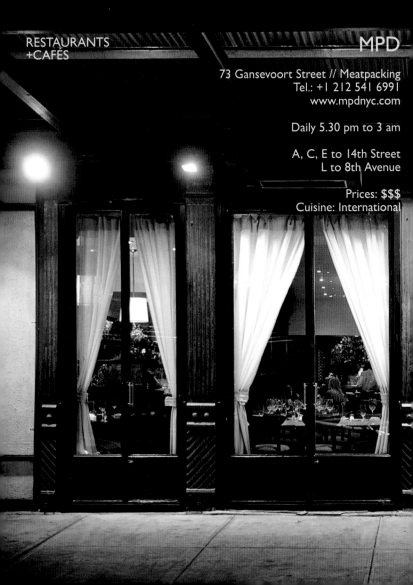

RESTAURANTS
+CAFÉS

MPD

73 Gansevoort Street // Meatpacking
Tel.: +1 212 541 6991
www.mpdnyc.com

Daily 5.30 pm to 3 am

A, C, E to 14th Street
L to 8th Avenue

Prices: $$$
Cuisine: International

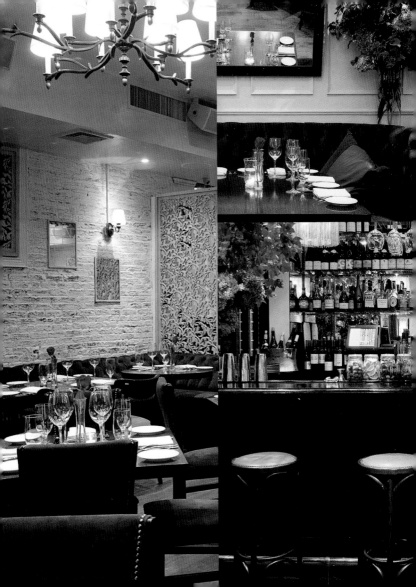

The abbreviation does not only stand for the location in Manhattan's club mecca, the Meatpacking District, but for Mon Petit Déjeuner. Yet nightlife takes center stage, as is to be expected from club impresarios Derek and Daniel Koch. After midnight the bar of the French restaurant transforms into an exclusive dance club. And after a night of partying, what could be better than a hearty breakfast!

Die Abkürzung steht nicht nur für die Lage im Club-Mekka Manhattans, dem Meatpacking District, sondern auch für Mon Petit Déjeuner. Wie jedoch nicht anders von den Nightlife-Impressarios Derek und Daniel Koch zu erwarten, spielt das Nachtleben die Hauptrolle. Nach Mitternacht verwandelt sich die Bar des französischen Restaurants in einen exklusiven Tanzclub. Und was ist nach einer durchfeierten Nacht schöner als ein ordentliches Frühstück!

Cette abréviation désigne la situation géographique, le Meatpacking District, quartier branché de Manhattan célèbre pour ses boîtes de nuit, mais aussi Mon Petit Déjeuner. Comme on pouvait s'y attendre avec Derek et Daniel Koch, imprésarios du monde de la nuit, la vie nocturne y occupe une place centrale. Après minuit, le bar du restaurant français se transforme en une boîte de nuit exclusive. Et quoi de mieux qu'un petit-déjeuner digne de ce nom après une nuit de fête bien arrosée !

La abreviatura no es por la localización en la Meca de los clubs de Manhattan, el Meatpacking District, sino también por Mon Petit Déjeuner. La vida nocturna juega el papel principal, como era de esperar de los empresarios de la noche Derek y Daniel Koch. Tras la medianoche el bar del restaurante francés se transforma en una exclusiva discoteca. Y, ¡qué hay mejor tras una noche de juerga que un buen desayuno!

SPICE MARKET

Tel.: + 1 212 675 2322
www.spicemarketnewyork.com

Mon–Wed, Sun noon to midnight
Fri–Sat noon to 1 am

A, C, E to 14th Street
L to 8th Avenue

Prices: $$$
Cuisine: Fusion

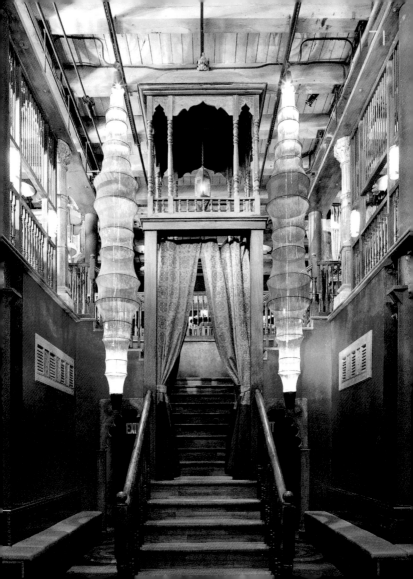

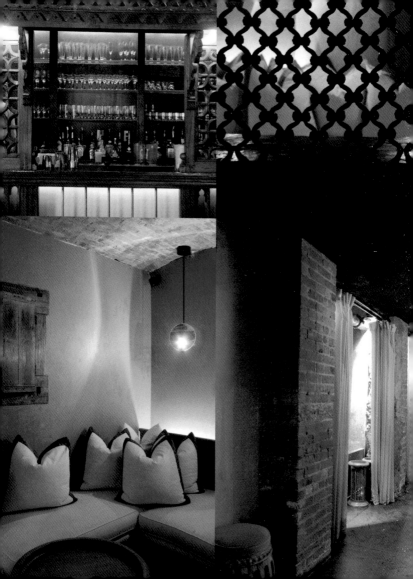

The spectacular environment is a festival for the senses, where Southeast Asian snacks—like those sold by street vendors in Thailand or Vietnam—are served. Teak pagodas, subdued golden light, artifacts from India and Burma, all crowned with luxurious, exotic fabrics, create the setting for star chef Jean-Georges Vongerichten's sophisticated version of Asian snack food. The elegant bar on the ground floor also serves exquisite dishes.

Die spektakuläre Umgebung, in der südostasiatische Snacks serviert werden, wie sie die Straßenverkäufer in Thailand oder Vietnam anbieten, ist ein Fest für die Sinne. Teakholzpagoden, gedämpftes goldenes Licht, Artefakte aus Indien und Burma und dazu luxuriöse exotische Stoffe bilden den Rahmen für Starkoch Jean-Georges Vongerichtens raffinierte Version asiatischer Imbisskost. Auch die elegante Bar im Parterre serviert die erlesenen Speisen.

Cet environnement spectaculaire où sont servis des snacks d'Asie du Sud-Est, comme les proposent les vendeurs de rue en Thaïlande ou au Vietnam, est une véritable fête pour les sens. Des pagodes en teck, une lumière dorée tamisée, des artéfacts d'Inde et de Birmanie, et des tissus exotiques précieux constituent le décor dans lequel Jean-Georges Vongerichten, chef étoilé, propose une version raffinée des snacks asiatiques. On peut également se restaurer dans l'élégant bar du rez-de-chaussée.

El espectacular entorno, en el que se sirven aperitivos del sudeste asiático como los que ofrecen los vendedores callejeros de Tailandia o Vietnam, es una fiesta para los sentidos. Pagodas de madera de teca, tenue luz dorada, artefactos de la India y Burma y lujosos tejidos exóticos forman el marco para la refinada versión de la cocina asiática del reconocido cocinero Jean-Georges Vongerichten. Los selectos platos también se sirven en el elegante bar de la planta baja.

THE BRESLIN

16 W 29th Street // NoMad
Tel.: +1 212 679 1939
www.thebreslin.com

Daily 7 am to midnight
Bar noon to 4 am

N, R to 28th Street

Prices: $$$
Cuisine: American-International

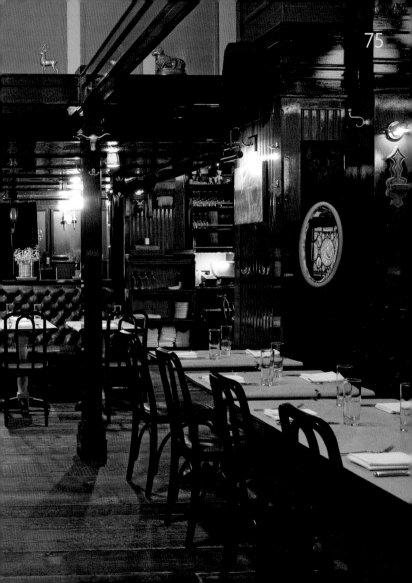

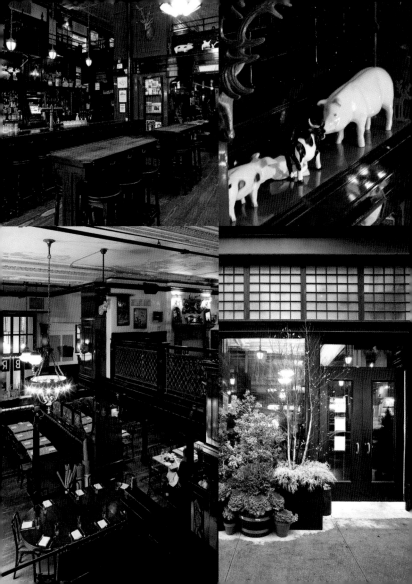

The gastropub at the Ace Hotel is paradise for meat lovers. From the head to the tip of the tail, everything is used to make sophisticated entrées, terrines, and house-made sausages. Whole roasted suckling pigs are available for large groups on request. Clever manipulation of the space creates an intimate atmosphere with many small alcoves. And behind the curtains of the private booths you can remain undisturbed: the waiter comes only when you push the call button.

Das Gastropub im Ace Hotel ist ein Paradies für Fleischliebhaber. Vom Kopf bis zum Schwanzende wird hier alles in raffinierten Hauptgerichten, Terrinen und hausgemachten Würsten verarbeitet. Für große Gruppen gibt es auf Wunsch ganze gebratene Spanferkel. Die intelligente Raumteilung schafft mit vielen kleinen Alkoven eine intime Atmosphäre. Und in den mit Vorhängen abgetrennten Separees ist man ganz privat: Die Bedienung kommt nur per Knopfdruck.

Ce pub gastronomique de l'Ace Hotel est un véritable paradis pour les amateurs de viande. De la tête à la queue, ici, tout est transformé en plats raffinés, terrines et saucisses maison. Sur demande, les groupes peuvent se faire servir du cochon de lait. Grâce à une répartition intelligente des pièces offrant de nombreuses petites alcôves, l'atmosphère se veut intimiste. Et dans de petites pièces isolées par des rideaux, on se retrouve en privé ; les serveurs n'y viennent qu'à la demande.

El pub gastronómico en el Ace Hotel es un paraíso para los amantes de la carne. Desde la cabeza hasta el rabo, todo se aprovecha para elaborar refinados platos principales, guisos o salchichas caseras. Para grupos numerosos se ofrecen cochinillos asados enteros por encargo. El inteligente aprovechamiento del espacio, con muchas alcobas pequeñas, logra crear una atmósfera íntima. Además, en los apartados divididos mediante cortinas se disfruta de total privacidad: el camarero acude solo si se aprieta un botón.

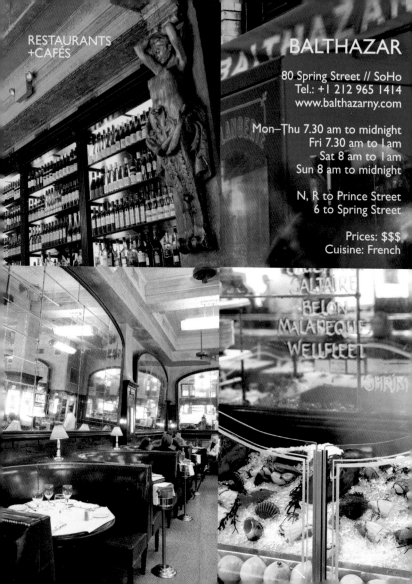

RESTAURANTS
+CAFÉS

BALTHAZAR

80 Spring Street // SoHo
Tel.: +1 212 965 1414
www.balthazarny.com

Mon–Thu 7.30 am to midnight
Fri 7.30 am to 1 am
Sat 8 am to 1 am
Sun 8 am to midnight

N, R to Prince Street
6 to Spring Street

Prices: $$$
Cuisine: French

This classic brasserie in SoHo is the perennial hit among Keith McNally's Francophile establishments. With its dark red benches and mirrors labeled with wine categories, it is an homage to Paris of the early 20th century. Even ten years after opening it still has a large draw: dinner reservations are taken up to 30 days in advance, or alternatively you might go for breakfast or a post-midnight meal.

Der Dauerbrenner unter Keith McNallys frankophilen Etablissements ist diese klassische Brasserie in SoHo. Mit ihren dunkelroten Sitzbänken und den mit Weinkategorien beschrifteten Spiegeln ist sie eine Hommage an das Paris des frühen 20. Jahrhunderts. Auch zehn Jahre nach Eröffnung ist der Andrang groß: Dinner-Reservierungen werden bis zu 30 Tage im Voraus angenommen, alternativ lohnt sich ein Besuch zum Frühstück oder Nachmitternachtsmahl.

Cette brasserie classique de l'établissement francophile situé dans le quartier de SoHo et dirigé par Keith McNally tient le haut de l'affiche. Avec ses banquettes bordeaux et ses miroirs où sont inscrits les différents vins, elle est un hommage au Paris du début du XX^e siècle. Dix ans après son ouverture, la clientèle continue d'affluer ; des réservations de dîner sont enregistrées jusqu'à 30 jours à l'avance. En alternative, un petit-déjeuner ou une collation après minuit vaut le détour.

El más exitoso y veterano de los establecimientos francófilos de Keith McNally es esta clásica brasería en el SoHo. Con sus bancos de un rojo oscuro y sus espejos con inscripciones de tipos de vinos es un homenaje al París de principios del siglo XX. Incluso diez años después de su inauguración está muy solicitado: las reservas para cenar se realizan con hasta 30 días de antelación, como alternativa vale la pena pasarse para desayunar o para el snack de medianoche.

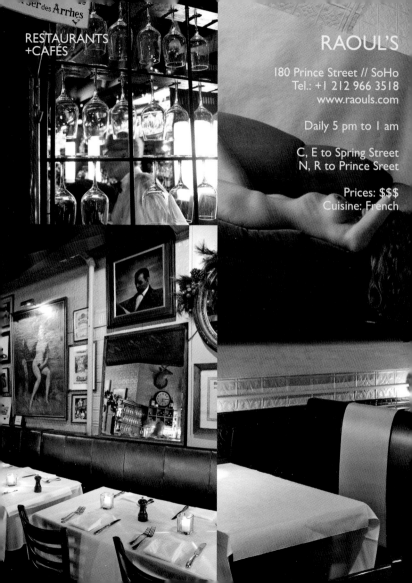

RESTAURANTS
+CAFÉS

RAOUL'S

180 Prince Street // SoHo
Tel.: +1 212 966 3518
www.raouls.com

Daily 5 pm to 1 am

C, E to Spring Street
N, R to Prince Sreet

Prices: $$$
Cuisine: French

Long before SoHo became fashionable and advanced to one of the most desirable and expensive gallery and shopping districts, the Raoul Brothers opened their artist bistro. That was over 30 years ago and it is still one of the hottest meeting places today, whether for lunch in the covered garden, dinner in the loft where guests can have their fortunes told, or for a drink at the bar. You won't find better steak frites anywhere in the city.

Lange bevor SoHo chic wurde und zu einem der begehrtesten und teuersten Galerie- und Shoppingviertel avancierte, eröffneten die Raoul-Brüder das Künstlerbistro. Das ist nun über 30 Jahre her, und noch heute ist es einer der angesagtesten Treffpunkte: ob für Lunch im überdachten Garten, Dinner im Loft, wo Gäste sich von einem Wahrsager die Zukunft deuten lassen, oder für einen Drink an der Bar. Ein besseres Steak Frites gibt es nirgendwo in der Stadt.

VALESCA GUERRAND
HERMES'S SPECIAL TIP

It's a casual cool, downtown place that's been around forever. Great steak frites, and you never know who you're going to see.

Bien avant que SoHo ne devienne chic et se transforme en l'un des quartiers dédiés aux galeries et au shopping les plus prisés et les plus chers, les frères Raoul y ont ouvert ce bistrot d'artistes. Bien que cela remonte à plus de 30 ans, cet établissement est restée l'une des adresses les plus en vogue : pour un déjeuner dans le jardin couvert, un verre au bar ou un dîner dans le loft, où les clients peuvent se faire prédire l'avenir par un voyant. On y mange également le meilleur steak frites de la ville.

Mucho antes de que el SoHo se pusiera de moda y se convirtiera en uno de los barrios de galerías y compras más cotizados y caros, los hermanos Raoul abrieron el bistró cultural. De esto hace mas de 30 años y, todavía hoy, es uno de los puntos de encuentro más de moda: ya sea para comer en el jardín cubierto, cenar en el loft, donde un adivino lee el futuro a los huéspedes, o tomar una copa en el bar. El filete con patatas es el mejor de la ciudad.

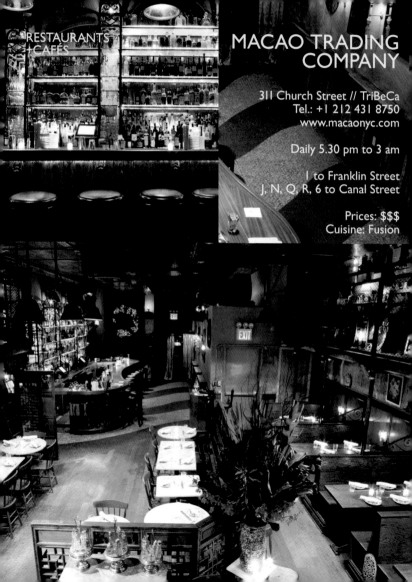

RESTAURANTS
+CAFÉS

MACAO TRADING COMPANY

311 Church Street // TriBeCa
Tel.: +1 212 431 8750
www.macaonyc.com

Daily 5.30 pm to 3 am

1 to Franklin Street
J, N, Q, R, 6 to Canal Street

Prices: $$$
Cuisine: Fusion

Named for a former Portuguese colony in China, the restaurant does justice to its namesake in decor and cuisine. An opulent balustrade encircles the dining room on the upper level, where specialties from both continents are served. The cherry-red bar on the ground floor evokes an opium den with its oversized pillows and plush seating groups, and offers plenty of exotic cocktails in addition to the full menu.

Das nach der ehemaligen portugiesischen Kolonie in China benannte Restaurant wird seinem Namensgeber in Dekor und Küche gerecht. Eine opulente Balustrade umrahmt den Speiseraum in der oberen Etage, wo Spezialitäten aus beiden Kontinenten serviert werden. Die in Kirschrot gehaltene Bar im Parterre erinnert mit ihren übergroßen Kissen und plüschigen Sitzecken an eine Opiumhöhle und bietet neben dem kompletten Menü eine Vielzahl an exotischen Cocktails.

Au vu de son décor et de sa cuisine, on comprend pourquoi ce restaurant fut nommé d'après le nom d'une ancienne colonie portugaise en Chine. Une opulente balustrade entoure la salle du premier étage où sont servies des spécialités des deux continents. Au rez-de-chaussée, avec ses coussins surdimensionnés et ses banquettes moelleuses, le bar, qui arbore un superbe rouge cerise, évoque une fumerie à opium et propose un menu complet ainsi qu'une large palette de cocktails exotiques.

La decoración y la cocina de este restaurante hacen honor a su nombre, el de una colonia antigua portuguesa en China. Una opulenta balaustrada envuelve el comedor en la planta superior, donde se sirven las especialidades de ambos continentes. El bar rojo cereza de la planta baja recuerda, con sus cojines sobredimensionados y sus tresillos de felpa, a un fumadero de opio, y ofrece una gran variedad de cócteles exóticos junto al completo menú.

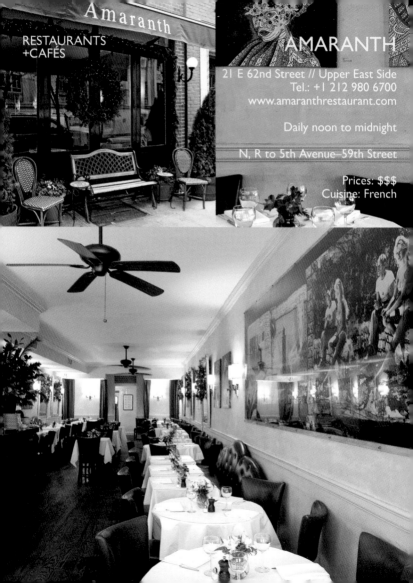

The sophisticated Mediterranean dishes are always prepared using fresh ingredients directly imported from France and Italy. Focaccia robiola—flat bread filled with robiola cheese and sprinkled with truffle oil, baked in a wood-fired oven—is a classic that is constantly winning new fans. The terrace offers a good vantage for observing the hubbub of shoppers along Madison Avenue.

Für die Zubereitung der raffinierten, mediterranen Speisen werden stets frische, direkt aus Frankreich und Italien importierte Zutaten verwendet. Das im Holzofen gebackene Focaccia Robiola – mit Trüffelöl besprengtes und Robiola-Käse gefülltes Fladenbrot – ist ein Klassiker und erfreut sich einer ständig wachsenden Fangemeinde. Von der Terrasse lässt sich das geschäftige Treiben der Shopper entlang der Madison Avenue hervorragend beobachten.

VALESCA GUERRAND HERMES'S SPECIAL TIP

Upper East Side chic at it's most casual.

Des produits frais importés directement et continuellement de France et d'Italie sont utilisés pour la préparation des plats méditerranéens raffinés. La Focaccia robiola, une fougasse arrosée d'huile de truffe et farcie au fromage robiola, cuite au four à bois, est un classique au succès toujours grandissant. Depuis la terrasse, on peut parfaitement observer l'effervescence des accrocs de shopping le long de la Madison Avenue.

Para la preparación de los refinados platos mediterráneos se emplean siempre ingredientes frescos, importados directamente desde Francia e Italia. La Focaccia robiola cocinada en horno de leña —pan plano regado con aceite de trufa y relleno de queso robiola— es un clásico y su número de fans no para de crecer. Desde la terraza se puede contemplar estupendamente el movimiento de los compradores en Madison Avenue.

SHOPS

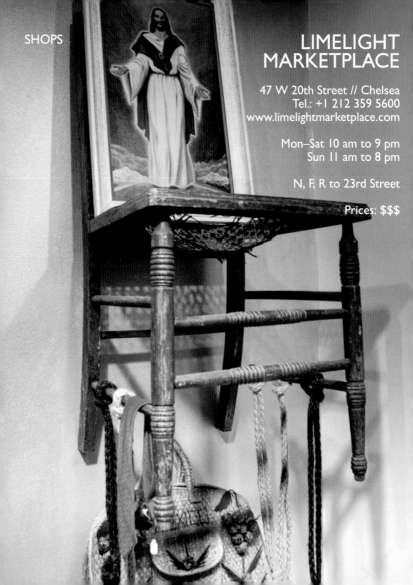

LIMELIGHT
MARKETPLACE

47 W 20th Street // Chelsea
Tel.: +1 212 359 5600
www.limelightmarketplace.com

Mon–Sat 10 am to 9 pm
Sun 11 am to 8 pm

N, F, R to 23rd Street

Prices: $$$

In the '80s, The Limelight nightclub held court in the neglected Gothic Revival church in Chelsea and was one of the city's hottest and most notorious dance temples until it closed in 2003. A luxury-class shopping mall opened last year in the once-hallowed halls following a thorough renovation. The soaring nave sets the scene for the 60 exclusive brands displaying their merchandise in miniature shops.

In der verlassenen neogotischen Kirche in Chelsea hielt in den 80er Jahren der Limelight-Club Hof und war bis zu seiner Schließung 2003 einer der angesagtesten und berüchtigtsten Tanztempel der Stadt. Nach einer Rundumrenovierung eröffnete im vergangenen Jahr in den einst heiligen Hallen eine Shopping Mall der Luxusklasse. Das hoch emporragende Kirchenschiff bildet die Kulisse für die 60 Nobelmarken, die ihre Waren in Miniaturlädchen ausstellen.

Dans les années 80, le club Limelight élut résidence dans l'église néogothique abandonnée de Chelsea et fut jusqu'à sa fermeture en 2003 l'un des temples de la danse les plus en vogue et décriés. L'année dernière, après une rénovation complète, un centre commercial luxueux a vu le jour en cet endroit jadis sacré. La nef qui s'élance vers le ciel accueille en son sein 60 grandes marques qui présentent leurs produits dans des boutiques miniatures.

En los años 80 y hasta su cierre en 2003, el club Limelight se hospedaba en la abandonada iglesia neogótica en Chelsea, siendo uno de los templos de baile más famosos y polémicos de la ciudad. Tras una completa renovación, un centro comercial de lujo abrió el pasado año en las otrora santas naves. La altísima nave principal forma el escenario para 60 marcas de prestigio, las cuales presentan sus productos en tiendas en miniatura.

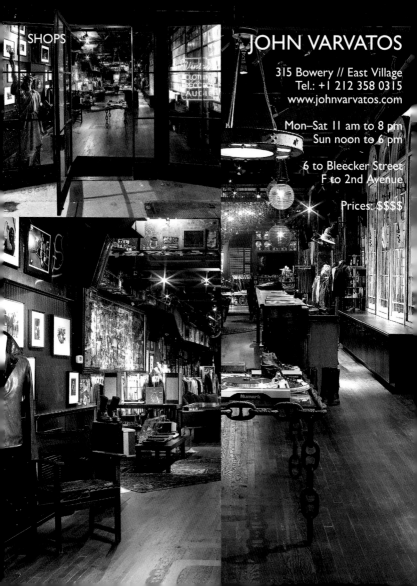

SHOPS

JOHN VARVATOS

315 Bowery // East Village
Tel.: +1 212 358 0315
www.johnvarvatos.com

Mon–Sat 11 am to 8 pm
Sun noon to 6 pm

6 to Bleecker Street
F to 2nd Avenue

Prices: $$$$

The third branch of the "rock 'n' roll designer" opened in what was formerly CBGB club on the Bowery, the birthplace of punk. As an homage to the legendary club, part of the original wall, covered with graffiti and tattered posters, was kept and preserved behind glass like a museum exhibit. Live performances by underground bands on a small stage keep the old club spirit alive.

In den ehemaligen Räumen des CBGB auf der Bowery, der Geburtsstätte des Punk, eröffnete die dritte Filiale des „Rock 'n' Roll-Designers". Als Hommage an den legendären Club wurde ein Teil der ursprünglichen, mit Graffiti besprühten und mit zerschlissenen Postern beklebten Mauer erhalten und wie ein Museumsstück von Glasscheiben geschützt. Live-Auftritte von Underground-Bands auf einer kleinen Bühne lassen den alten Clubgeist wieder aufleben.

La troisième boutique du « designer rock 'n' roll » a ouvert ses portes dans les anciens locaux du CBGB situés dans la Bowery, berceau de la culture punk. En hommage au club légendaire, une partie des graffitis d'origine et des posters déchirés qui recouvraient les murs ont été préservés et sont conservés sous verre comme des pièces de musée. Sur une petite scène, des concerts de groupes underground ravivent l'esprit d'origine du club.

En las antiguas habitaciones del CBGB en el Bowery, la cuna del punk, abrió la tercera filial del "diseñador del Rock". Como homenaje al legendario club se conservó tras vitrinas una parte de los muros originales con sus graffitis y sus desgastados pósters, como si de piezas de museo se tratara. El antiguo espíritu de los clubs vuelve a la vida cuando los grupos underground actúan en directo sobre el pequeño escenario.

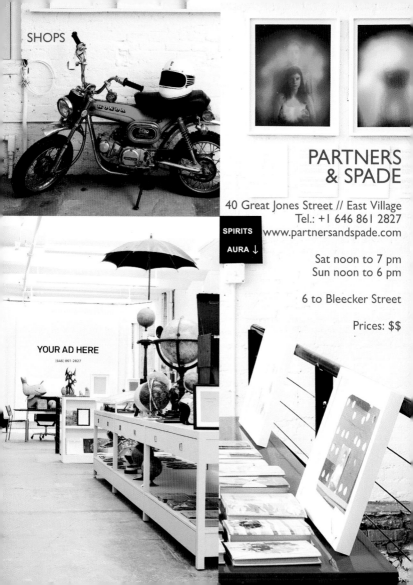

SHOPS

PARTNERS & SPADE

40 Great Jones Street // East Village
Tel.: +1 646 861 2827
www.partnersandspade.com

SPIRITS

AURA ↓

Sat noon to 7 pm
Sun noon to 6 pm

6 to Bleecker Street

Prices: $$

YOUR AD HERE
(646) 861-2827

If it exists, they've got it here. The pop-art flea market is half gallery and half shop, a combination of art and commerce with a sense of humor and a sense of the unusual. All manner of gewgaws fill countless drawers and shelves—sometimes you need a ladder to reach the item you're interested in. There are also fanciful creations by a variety of designers. If you still can't find what you're looking for, you can special-order a custom piece.

Hier gibt es nichts, was es nicht gibt. Der Pop-Art-Flohmarkt ist halb Galerie und halb Laden, eine Kombination aus Kunst und Kommerz mit Sinn für Humor und Außergewöhnliches. Nippes aller Art füllt unzählige Schubladen und Regale, und mitunter gelangt man nur mithilfe einer Leiter an das ersehnte Stück. Daneben finden sich ausgefallene Kreationen diverser Designer. Wer partout nicht fündig wird, kann sich auf Wunsch Sonderstücke anfertigen lassen.

Ici, vous dénicherez tout ce que vous cherchez. Ce bric-à-brac pop art fait à la fois office de galerie et de boutique et combine l'art et le commerce faisant la part belle à l'humour et l'insolite. Des babioles de toute sorte inondent tiroirs et étagères. Sans l'échelle, il est impossible d'atteindre l'objet convoité. Des créations insolites de plusieurs designers sont également exposées. Ceux qui n'ont pas trouvé leur bonheur peuvent faire fabriquer des pièces uniques sur commande.

No hay nada que no se encuentre aquí. El mercadillo pop art es mitad galería mitad tienda, una combinación de arte y comercio con sentido del humor y cosas extraordinarias. Baratijas de todas clases llenan innumerables cajones y estanterías y, a veces, el artículo deseado se alcanza solo con ayuda de una escalera. Al lado se encuentran extravagantes colecciones de diversos diseñadores. Quien no encuentre absolutamente nada de lo que busca, puede hacerse artículos exclusivos a medida.

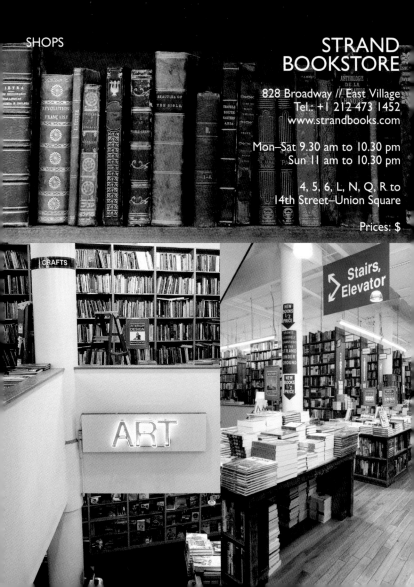

SHOPS

STRAND
BOOKSTORE

828 Broadway // East Village
Tel.: +1 212 473 1452
www.strandbooks.com

Mon–Sat 9.30 am to 10.30 pm
Sun 11 am to 10.30 pm

4, 5, 6, L, N, Q, R to
14th Street–Union Square

Prices: $

The Strand opened in 1927 on Book Row in the East Village. Of the 48 shops located there at the time, only the Strand remains—the city's largest independent bookstore today. This book lovers' paradise rightly advertises with the slogan "18 Miles of Books." An enormous selection of literature fills floor-to-ceiling shelves on four floors. Collectors come here for rare editions, art books, and antiquarian volumes.

1927 eröffnete der Strand auf der sogenannten Buchgasse im East Village. Von den 48 damals dort ansässigen Läden ist nur Strand übrig geblieben – heute der größte unabhängige Buchladen der Stadt. Zu Recht wirbt dieses Paradies für Buchliebhaber mit dem Slogan „18 Miles of Books". Auf vier Etagen füllt eine enorme Auswahl an Lesestoff deckenhohe Regalreihen. Sammler finden hier seltene Editionen, Kunst- und antiquarische Bücher.

La librairie Strand a ouvert ses portes en 1927 dans la « rue du livre » du quartier d'East Village. À l'époque, on y comptait 48 librairies. De nos jours, seule Strand, désormais la plus grande librairie indépendante de la ville, est restée. Ce paradis des amateurs de livres affiche le slogan « 18 Miles of Books ». Et pour cause ! Sur quatre étages, il arbore une gamme gigantesque de livres sur des étagères montant jusqu'au plafond. Les collectionneurs y trouvent des éditions rares, des livres d'art et livres anciens.

En 1927 abrió sus puertas el Strand en el llamado callejón de los libros del East Village. De las 48 tiendas que había en un principio solo queda el Strand; es hoy la librería independiente más grande de la ciudad. Este paraíso para los amantes de los libros se anuncia con razón con el eslogan "18 Miles of Books". En cuatro pisos, una enorme variedad de lecturas llena estanterías que llegan hasta el techo. Los coleccionistas encuentran aquí ediciones poco corrientes y libros de arte y antiguos.

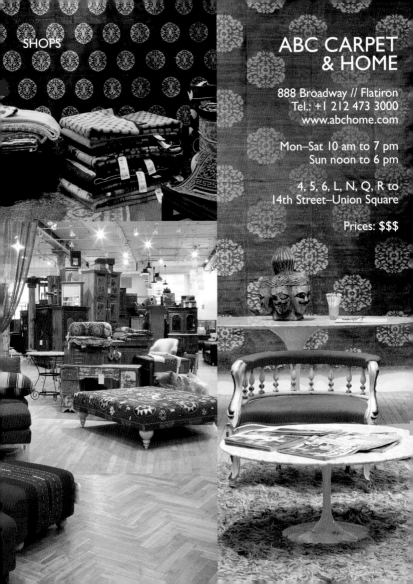

SHOPS

ABC CARPET & HOME

888 Broadway // Flatiron
Tel.: +1 212 473 3000
www.abchome.com

Mon–Sat 10 am to 7 pm
Sun noon to 6 pm

4, 5, 6, L, N, Q, R to
14th Street–Union Square

Prices: $$$

Whether the search is for an 18th-century garden bench, Moroccan mosaic tiles, or a piece of sandalwood soap, this family business—which started from the humble beginnings of a carpet merchant more than 100 years ago—is the ultimate emporium for fixtures and furnishings of all kinds. A large part of the selection is produced from environmentally friendly materials in small craft enterprises all over the world.

Ob auf der Suche nach einer Gartenbank aus dem 18. Jahrhundert, marokkanischen Mosaikfliesen oder einem Stück Sandelholzseife: Der Familienbetrieb hat sich vor über 100 Jahren aus den bescheidenen Anfängen eines Teppichhändlers entwickelt und ist das ultimative Warenhaus für Einrichtungsgegenstände aller Art. Ein großer Teil des Sortiments ist aus umweltfreundlichen Materialien hergestellt und wird in kleinen Handwerksbetrieben in aller Welt gefertigt.

Si vous recherchez un banc de jardin du XVIII^e siècle, des carreaux de mosaïque du Maroc ou un savon de bois de santal, ce grand magasin dédié à la décoration intérieure sous toutes ses formes est fait pour vous. Cette entreprise familiale, qui a débuté modestement il y a plus d'une centaine d'années comme boutique de tapis, est incontournable. Une grande partie de sa gamme est produite à base de matériaux écologiques et fabriquée dans de petites entreprises artisanales du monde entier.

Ya se busque un banco de jardín del siglo XVIII, azulejos de mosaico marroquíes o un trozo de jabón de madera de sándalo: el negocio familiar, construido durante más de 100 años desde sus modestos comienzos como tienda de alfombras, es el almacén total para objetos del hogar de todo tipo. Una gran parte del surtido está confeccionado con materiales respetuosos con el medio ambiente y se produce en talleres artesanos de todo el mundo.

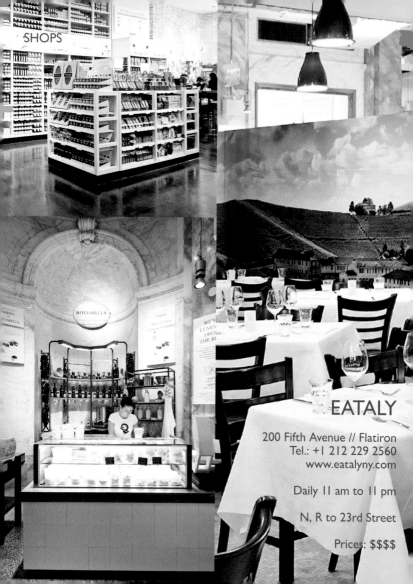

SHOPS

EATALY

200 Fifth Avenue // Flatiron
Tel.: +1 212 229 2560
www.eatalyny.com

Daily 11 am to 11 pm

N, R to 23rd Street

Prices: $$$$

Everything in the almost 54,000 sq. ft. of space here is concerned with food from Italy. Visitors can shop, taste, and learn Italian cookery. Numerous restaurants provide food and drink, and various shops offer the right ingredients and utensils for the culinary delights. A cooking school gives tips for proper and authentic preparation. The rooftop beer garden is open year-round.

Auf knapp 5 000 m² dreht sich hier alles um Kulinarisches aus Italien. Besucher können einkaufen, probieren und italienische Kochkunst erlernen. Für das leibliche Wohl sorgt eine Vielzahl an Restaurants, und diverse Läden bieten die richtigen Zutaten und Koch-utensilien für die kulinarischen Genüsse. Eine Kochschule offeriert Tipps für die korrekte und authentische Zubereitung. Der Biergarten auf der Dachterrasse ist das ganze Jahr über geöffnet.

Un temple de la gastronomie italienne sur une surface d'environ 5 000 m². Les visiteurs peuvent y faire leurs achats, goûter et apprendre la cuisine italienne. Pour la plus grande joie des palais gourmands, une multitude de restaurants et magasins proposent les bons ingrédients et ustensiles indispensables aux plaisirs culinaires. Une école de cuisine délivre de précieux conseils pour une prépa-ration dans les règles de l'art. La terrasse sur le toit est ouverte toute l'année.

En casi 5 000 m² todo gira en torno a la cocina italiana. Los visitantes pueden comer, probar y aprender el arte culinario italiano. Del bienestar físico se ocupan un gran número de restaurantes y diversas tiendas ofrecen los ingredientes adecuados y los utensilios de cocina para los placeres culinarios. Una escuela de cocina propone consejos para la correcta y auténtica preparación. El bar terraza sobre la azotea está abierto todo el año.

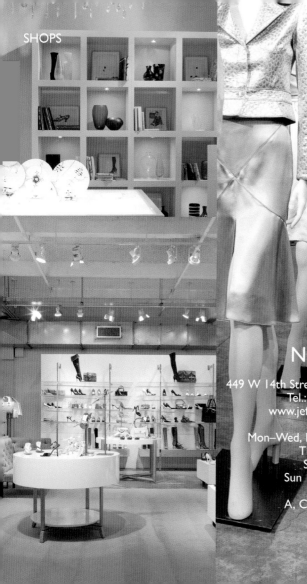

SHOPS

JEFFREY
NEW YORK

449 W 14th Street // Meatpacking
Tel.: +1 212 206 1272
www.jeffreynewyork.com

Mon–Wed, Fri 10 am to 8 pm
Thu 10 am to 9 pm
Sat 10 am to 7 pm
Sun 12.30 pm to 6 pm

A, C, E to 14th Street
L to 8th Avenue

Prices: $$$$

The exclusive mini-department store in a warehouse in the Meatpacking District offers a mix of established and up-and-coming designer brands. A DJ plays records, giving the beats to which customers poke around in the latest Prada or Libertine collections. Shoe lovers in particular wax lyrical about the place. For years owner Jeffrey Kalinsky was a shoe buyer for the fashion store Barney's, and his passion and expertise are evident in the exquisite selection.

Das Mini-Nobelkaufhaus in einer Lagerhalle im Meatpacking District bietet eine Mischung aus etablierten und aufstrebenden Designermarken. Ein DJ legt Platten auf, zu deren Beats Kunden in den neuesten Prada- oder Libertine-Kollektionen stöbern. Besonders Schuhliebhaber geraten hier ins Schwärmen. Inhaber Jeffrey Kalinsky war lange Schuheinkäufer für das Modehaus Barney's, und seine Passion und Expertise zeigt sich in dem exquisiten Sortiment.

Ce mini grand magasin chic, situé dans un dépôt de Meatpacking District, offre une belle palette de marques de designers, établies ou en pleine expansion. Un DJ enflamme les platines. Au son de ses beats, les clients plongent dans les toutes dernières collections Prada ou Libertine. Pour les amateurs de chaussures, un véritable paradis. Jeffrey Kalinsky, le propriétaire, a longtemps été acheteur de chaussures pour la maison de luxe Barney's. Sa passion et son expérience reflètent cette gamme de première classe.

El pequeño y lujoso centro comercial en un almacén del Meatpacking District ofrece una mezcla de marcas de diseño establecidas y florecientes. Los clientes rebuscan entre las nuevas colecciones de Prada o Libertine al ritmo de la música que pincha un DJ. Los amantes de los zapatos son los que más se apasionan aquí. El dueño, Jeffrey Kalinsky, fue durante mucho tiempo comprador de zapatos para la casa de moda Barney's y su pasión y experiencia se aprecian en el exquisito surtido.

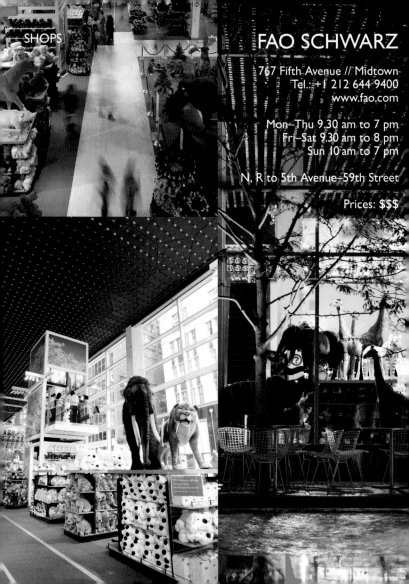

SHOPS

FAO SCHWARZ

767 Fifth Avenue // Midtown
Tel.: +1 212 644 9400
www.fao.com

Mon–Thu 9.30 am to 7 pm
Fri–Sat 9.30 am to 8 pm
Sun 10 am to 7 pm

N, R to 5th Avenue–59th Street

Prices: $$$

The playtime wonderland on Fifth Avenue is an experience for more than just children. A uniformed doorman and life-size Steiff animals greet guests both big and small. A nearly endless array of toys are presented over two floors, from traditional wood playthings to the latest electronic gizmo. Visitors are invited to touch, experience, and try things out, and can even create their own design for all kinds of dolls and have them produced.

Das Spielzeugwunderland an der Fifth Avenue ist nicht nur für Kinder ein Erlebnis. Ein uniformierter Türsteher und lebensgroße Steifftiere begrüßen die großen und kleinen Gäste. Auf zwei Etagen gibt es ein schier unendliches Angebot an Spielsachen: von traditionellem Holz- bis zum neuesten Elektrospielzeug. Besucher sind eingeladen, alles anzufassen, zu erleben, auszuprobieren und können sogar Puppen jeder Art selbst entwerfen und herstellen lassen.

VALESCA GUERRAND HERMES'S SPECIAL TIP

It's a great place to take kids even if you're not looking for toys. (But you may leave with a few anyway.)

Ce royaume du jouet situé sur la Cinquième Avenue est un paradis de découvertes pour les enfants mais aussi les adultes. Un portier en uniforme et des sculptures d'animaux de taille réelle accueillent petits et grands clients. Sur deux étages, vous trouverez une offre infinie de jouets allant du jouet en bois traditionnel au jouet électronique dernier cri. Les visiteurs sont invités à toucher, expérimenter, essayer et peuvent même dessiner des poupées de toutes les sortes et les faire fabriquer.

El país de las maravillas de los juguetes en la Quinta Avenida no es solo una experiencia para los niños. Un portero uniformado y animales de peluche de tamaño real saludan a grandes y pequeños. En las dos plantas hay una oferta casi interminable de juguetes: desde los tradicionales de madera, hasta los más modernos juguetes electrónicos. Los visitantes pueden tocar, experimentar, probar e incluso diseñar ellos mismos muñecos de toda clase y ver cómo son fabricados.

MAP N° **31**

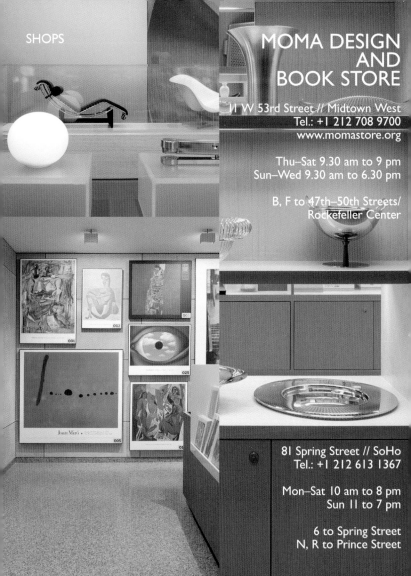

SHOPS

MOMA DESIGN AND BOOK STORE

11 W 53rd Street // Midtown West
Tel.: +1 212 708 9700
www.momastore.org

Thu–Sat 9.30 am to 9 pm
Sun–Wed 9.30 am to 6.30 pm

B, F to 47th–50th Streets/
Rockefeller Center

81 Spring Street // SoHo
Tel.: +1 212 613 1367

Mon–Sat 10 am to 8 pm
Sun 11 to 7 pm

6 to Spring Street
N, R to Prince Street

The two branches in Midtown and SoHo are no ordinary museum shops but are among the best design stores in town. Thanks to museum-worthy designs (selected by MoMA curators) of everything from household utensils to whimsically shaped lamps, it's the first stop for unusual gift ideas for the person who has everything and for things you didn't even know existed, much less that you need them.

Die zwei Filialen in Midtown und SoHo sind keine gewöhnlichen Museumsshops, sondern gehören zu den besten Designläden der Stadt. Dank des museums-würdigen und von Kuratoren des MoMA ausgewählten Designs von Haushaltsutensilien bis zu skurril geformten Lampen sind sie erste Anlaufstelle für ausgefallene Geschenkideen für diejenigen, die schon alles haben, und für Dinge, von denen man nicht wusste, dass es sie gibt, geschweige denn, dass man sie braucht.

VALESCA GUERRAND HERMES'S SPECIAL TIP

A great place to pick up fun and interesting gifts for all ages.

Les deux boutiques des quartiers de Midtown et SoHo ne sont pas de banales boutiques de musée, elles comptent parmi les meilleures boutiques de design de la ville. Arborant un design judicieusement sélectionné par la direction du MoMA et reflétant bien l'image du musée, les ustensiles ménagers, lampes aux courbes originales et autres constituent des idées cadeaux insolites pour ceux qui ont déjà tout, des objets dont on ne connaissait pas l'existence et dont on n'a pas forcément besoin.

Las dos filiales en Midtown y el SoHo no son tiendas museo corrientes, sino que pertenecen a las mejores tiendas de diseño de la ciudad. Gracias al diseño digno de museo, seleccionado por conservadores del MoMA, que va desde utensilios del hogar hasta lámparas con formas extravagantes, son el lugar idóneo donde encontrar regalos originales para aquellos que ya lo tienen todo, o cosas cuya existencia se desconocía y que no se necesitan en absoluto.

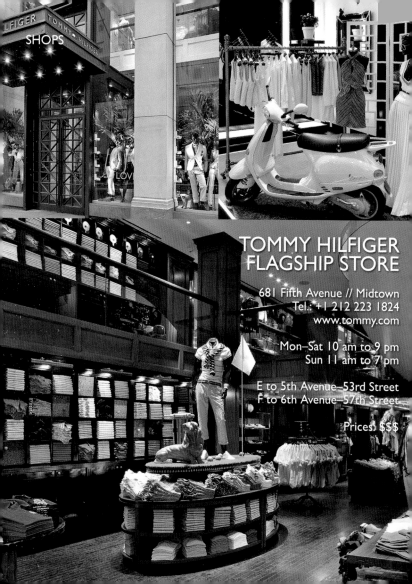

TOMMY HILFIGER
FLAGSHIP STORE

681 Fifth Avenue // Midtown
Tel.: +1 212 223 1824
www.tommy.com

Mon–Sat 10 am to 9 pm
Sun 11 am to 7 pm

E to 5th Avenue–53rd Street
F to 6th Avenue–57th Street

Prices: $$$

Shopping on Fifth Avenue is a definite must during your stay. Located in the center of Manhattan, the Tommy Hilfiger Store presents its collections throughout five floors. For 25 years the brand stands for classic-American cool fashion with a twist. The designer finds his inspiration in the icons and colors of the American lifestyle. Tommy Hilfiger is one of the leading fashion brands with his unique success story beginning in 1969 while selling customized jeans in his hometown.

Bei einem Besuch in New York gehört ein Einkaufsbummel auf der Fifth Avenue einfach dazu. Der Tommy Hilfiger Store lädt auf fünf Etagen zu einem echt amerikanischen Shoppingerlebnis ein. Seit 25 Jahren steht die Marke für klassisch-amerikanische, coole Mode, inspiriert von den Ikonen und Farben des amerikanischen „Way of Life". 1969 begann die einmalige Erfolgsstory damit, dass Tommy Hilfiger aufgepeppte Jeans verkaufte – heute steht sein Name für eines der bekanntesten Modelabels.

Il serait impensable, lors d'une visite à New York, de ne pas faire un tour par la Fifth Avenue ; tout particulièrement à la boutique Tommy Hilfiger qui vous fera vivre, sur ses cinq étages, une expérience « shopping » tout à fait à l'Américaine. Cette marque reflète depuis 25 ans la mode américaine classique et décontractée, inspirée par les icones et les couleurs de « l'art de vivre » à l'Américaine. Cette histoire à succès, unique en son genre, commença en 1969 lorsque Tommy Hilfiger vendait des jeans qui ne manquaient pas de pep. Aujourd'hui, son nom est à l'image d'une des griffes les plus connues.

Las tiendas de la Fifth Avenue suponen una visita obligatoria. La boutique de Tommy Hilfiger, en un local de cinco plantas en el corazón de Manhattan, exhibe las colecciones de una marca que, desde hace 25 años, encarna un estilo de moda clásica americana con un toque singular. Su diseñador se inspira en los íconos y colores del estilo de vida americano. Tommy Hilfiger comenzó su carrera en 1969 vendiendo vaqueros con apliques en su ciudad natal. Hoy su marca se encuentra entre las más cotizadas.

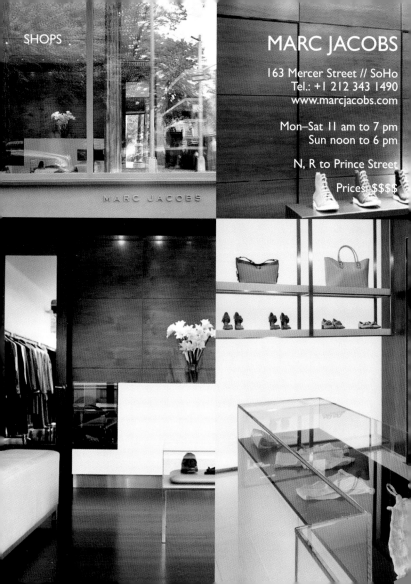

MARC JACOBS

163 Mercer Street // SoHo
Tel.: +1 212 343 1490
www.marcjacobs.com

Mon–Sat 11 am to 7 pm
Sun noon to 6 pm

N, R to Prince Street

Prices: $$$$

Bold colors, layered looks, and a hint of vintage are the characteristics of the retrochic cult brand by star designer Marc Jacobs. The various accessory lines are every bit as desirable as the ready-to-wear collection. The bags in particular are an absolute must for many fans. Along with his first New York location in SoHo, the darling of the fashion scene has several shops in the West Village carrying the more affordable Marc by Marc Jacobs line.

Kräftige Farben, Lagen-Look und ein Hauch von Vintage sind die Merkmale der Kultmarke des Retrochics von Stardesigner Marc Jacobs. Nicht weniger begehrt als die Ready-to-wear-Kollektion sind die diversen Accessoirelinien. Besonders die Taschen sind für viele Fans ein absolutes Muss. Neben seiner ersten New Yorker Filiale in SoHo eröffnete der Liebling der Modeszene mehrere Shops im West Village, die die günstigere Marc by Marc Jacobs-Linie führen.

Des coloris vifs, un style superposé et un soupçon de vintage, voici les caractéristiques de la marque culte au style rétro chic du créateur Marc Jacobs. Les accessoires ne sont pas moins convoités que la ligne de prêt-à-porter. La majorité des fans ne peuvent plus se passer des sacs. En plus de sa première boutique dans le quartier de SoHo, le créateur favori du milieu de la mode a ouvert plusieurs boutiques dans le West Village où la ligne à prix plus abordable, Marc by Marc Jacobs, y est proposée.

Colores fuertes, estilo de prendas sobrepuestas y una pizca de vintage son las características de la marca de culto del retrochic, firmada por el diseñador estrella Marc Jacobs. No menos deseadas que la colección prêt-à-porter son las diversas líneas de accesorios. Especialmente los bolsos son para muchos fans una auténtica obligación. Junto a su primera filial neoyorquina en el SoHo, el preferido del mundo de la moda abrió varias tiendas en West Village, las cuales venden la más económica línea Marc by Marc Jacobs.

CLUBS, LOUNGES +BARS

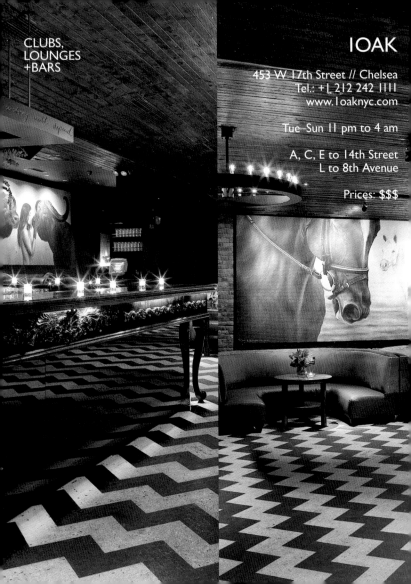

CLUBS,
LOUNGES
+BARS

1OAK

453 W 17th Street // Chelsea
Tel.: +1 212 242 1111
www.1oaknyc.com

Tue–Sun 11 pm to 4 am

A, C, E to 14th Street
L to 8th Avenue

Prices: $$$

The name refers to the acronym of the luxurious club that considers itself "one of a kind" as much as the oak paneling. Ostrich-leather chairs and horseshoe-shaped benches line the gold-draped walls of the spacious room commanded by a black-lacquered bar in the middle. Enormous wall paintings by Roy Nachum decorate the separate VIP area. Smokers can retreat to the partially glassed-in patio.

Der Name steht weniger für die Eichenholzverkleidung denn als Motto für den luxuriösen Club, der sich als „one of a kind" – einzigartig – sieht. Sessel aus Straußenleder und hufeisenförmige Bänke säumen die mit goldenen Vorhängen drapierten Mauern des weiträumigen Saals, in dessen Mitte eine schwarz lackierte Bar thront. Riesige Wandgemälde von Roy Nachum zieren den separaten VIP-Bereich. Raucher ziehen sich in den halb verglasten Patio zurück.

Son nom fait plutôt référence à la devise de ce club luxueux « one of a kind » (unique en son genre) qu'à l'habillage en chêne. Des fauteuils en cuir d'autruche et des banquettes en forme de fer à cheval s'affichent devant les murs drapés de tentures dorées de la vaste salle, au milieu de laquelle trône un bar noir laqué. D'immenses tableaux de Roy Nachum décorent l'espace VIP. Les fumeurs peuvent se retirer dans le patio partiellement vitré.

El nombre se refiere menos a la cubierta de madera de roble que al eslogan del lujoso club, el cual se ve a sí mismo como "one of a kind" —único. En la amplia sala, cuyo centro está dominado por una barra pintada de negro, sillones de cuero de avestruz y bancos con forma de herradura se adentran en los muros vestidos con cortinas doradas. Enormes murales de Roy Nachum adornan la zona VIP. Los fumadores se retiran al patio parcialmente acristalado.

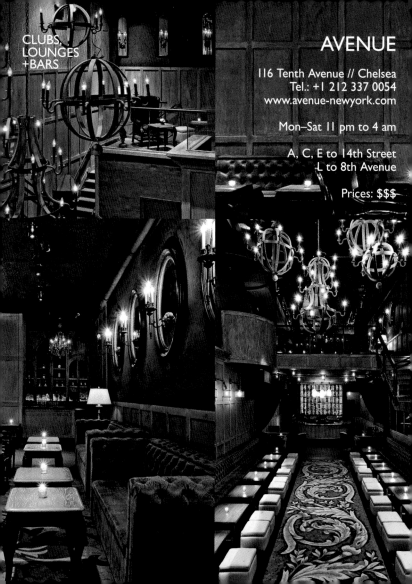

CLUBS,
LOUNGES
+BARS

AVENUE

116 Tenth Avenue // Chelsea
Tel.: +1 212 337 0054
www.avenue-newyork.com

Mon–Sat 11 pm to 4 am

A, C, E to 14th Street
L to 8th Avenue

Prices: $$$

The latest "in" spot is the city's first gastro-lounge. Club pioneer Noah Tepperberg's most recent project brings a complete menu to the relaxed surroundings of a bar with plentiful seating and a DJ. The music stays in the background and does not interrupt conversation. From the glassed-in gallery you can observe the activities at ground level, where the hip crowd makes itself comfortable by candlelight on long rows of leather benches.

Der neueste In-Treff ist die erste Gastro-Lounge der Stadt. Das jüngste Projekt von Club-Pionier Noah Tepperberg bringt ein komplettes Menü in die entspannte Umgebung einer Bar mit vielen Sitzgelegenheiten und DJ. Die Musik bleibt im Hintergrund und stört nicht bei der Unterhaltung. Von der verglasten Empore aus lässt sich das Treiben im Parterre beobachten, wo es sich das Szenevolk bei Kerzenlicht auf langen Reihen von Lederbänken bequem macht.

Le dernier établissement en vogue est ce lounge gastronomique, le premier de la ville. La toute dernière création du pionnier des boîtes de nuit, Noah Tepperberg, propose un menu complet dans le cadre décontracté d'un bar avec de nombreux sièges et des DJs. La musique est en sourdine et ne gêne pas les conversations. Depuis la galerie vitrée, on peut observer ce qui se passe au rez-de-chaussée, où la scène branchée se délasse sur de longues rangées de banquettes en cuir à la lueur des bougies.

El nuevo lugar de moda es el primer salón gastronómico de la ciudad. El último proyecto del pionero de los clubs Noah Tepperberg ofrece un menú completo en la relajada atmósfera de un bar, con muchos asientos y un DJ. La música se mantiene de fondo y permite conversar tranquilamente. Desde la tribuna acristalada se pueden observar los movimientos en la planta baja, donde el público de la escena se acomoda en largas filas de bancos de cuero a la luz de las velas.

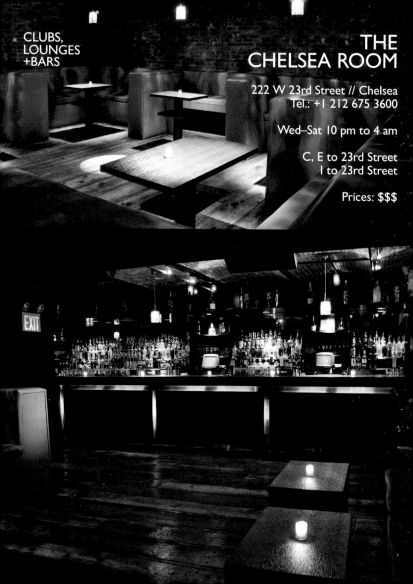

CLUBS,
LOUNGES
+BARS

THE
CHELSEA ROOM

222 W 23rd Street // Chelsea
Tel.: +1 212 675 3600

Wed–Sat 10 pm to 4 am

C, E to 23rd Street
1 to 23rd Street

Prices: $$$

For many decades the legendary Chelsea Hotel was both home and creative studio for a number of notable artists. Arthur Miller and Bob Dylan used it as their retreat and Andy Warhol filmed "Chelsea Girls" here. Some former residents paid the rent with their works. As a reminder of that golden era as the center of New York's art scene, the works are part of the decor of the nightclub and lounge in the hotel basement.

Über viele Jahrzehnte war das legendäre Chelsea Hotel für etliche namhafte Künstler sowohl Zuhause als auch Ort ihres Schaffens. Arthur Miller und Bob Dylan zogen sich hierher zurück, und Andy Warhol drehte „Chelsea Girls". Einige der ehemaligen Bewohner bezahlten die Miete mit ihren Arbeiten. Als Reminiszenz an jene glorreiche Zeit als Mittelpunkt der New Yorker Kunstszene sind die Werke Teil des Dekors der Nachtclub-Lounge im Keller des Hotels.

Durant de nombreuses décennies, bon nombre d'artistes renommés élurent domicile dans cet hôtel légendaire et y créèrent leurs œuvres. Arthur Miller et Bob Dylan s'y retirèrent et Andy Warhol y tourna « Chelsea Girls ». Certains d'entre eux payaient leur loyer grâce à leurs travaux. En souvenir de ces moments de gloire de la scène artistique new-yorkaise, les œuvres sont présentées dans la cave du night-club lounge de l'hôtel.

Durante muchas décadas, el legendario Chelsea Hotel fue tanto el hogar de numerosos artistas de renombre, como su lugar de trabajo. Arthur Miller y Bob Dylan encontraron aquí su retiro y Andy Warhol rodó „Chelsea Girls". Algunos de los antiguos habitantes pagaron el alquiler con sus trabajos. Como reminiscencia de aquella gloriosa época como centro de la escena cultural neoyorquina, las obras son parte de la decoración del club nocturno en el sótano del hotel.

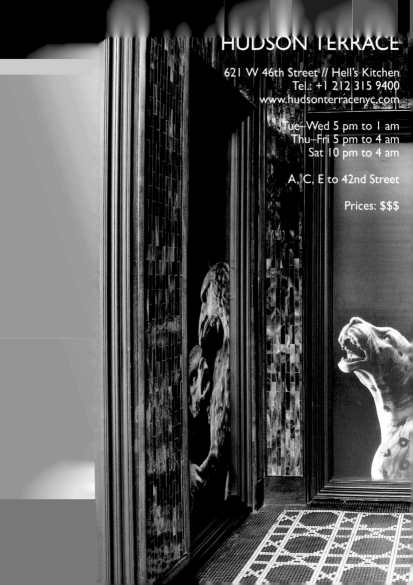

HUDSON TERRACE

621 W 46th Street // Hell's Kitchen
Tel.: +1 212 315 9400
www.hudsonterracenyc.com

Tue–Wed 5 pm to 1 am
Thu–Fri 5 pm to 4 am
Sat 10 pm to 4 am

A, C, E to 42nd Street

Prices: $$$

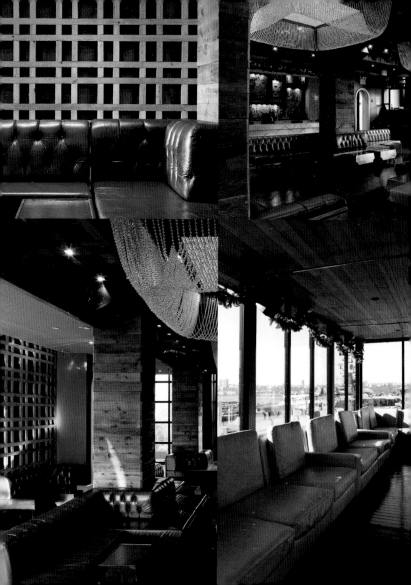

A visit to the roof deck of the two-story lounge in the far west of Midtown is recommended in every season, rain or shine. The temperature-stabilizing mahogany floor, open fireplace, and glassed-in cabanas make drinks on the deck possible even in winter as the sun sets over the Hudson River. The retractable awning gives protection when it's raining—or you might prefer to escape downstairs to the lounge.

Ein Besuch auf der Dachterrasse der zweistöckigen Lounge im äußersten Westen von Midtown lohnt sich zu jeder Jahreszeit und bei jedem Wetter. Der temperaturausgleichende Fußboden aus Mahagoni, ein offener Kamin und verglaste Cabanas erlauben auch im Winter einen Drink auf der Terrasse während die Sonne über dem Hudson untergeht. Bei Regen bietet das ausfahrbare Zeltdach Schutz – oder man flüchtet sich hinunter in den Salon.

À l'extrémité ouest de Midtown, le toit-terrasse de ce lounge sur deux étages vaut vraiment le détour, en toute saison et par tout temps. Grâce au plancher thermorégulateur en acajou, à la cheminée ouverte et la cabane vitrée, même en hiver, il est possible de siroter un verre en terrasse, tout en admirant le coucher de soleil sur l'Hudson. Par temps pluvieux, le toit pyramidal amovible offre sa protection ou on peut également se réfugier en bas dans le salon.

Una visita a la azotea del salón de dos plantas en el extremo oeste de Midtown vale siempre la pena, en cualquier época del año e independientemente del tiempo que haga. El suelo de caoba que regula la temperatura, una chimenea abierta y cabañas acristaladas permiten tomar algo en la azotea incluso en invierno, mientras el sol se oculta tras el Hudson. El techo de lona replegable ofrece protección frente a la lluvia, aunque también se puede huir hacia el salón de la planta inferior.

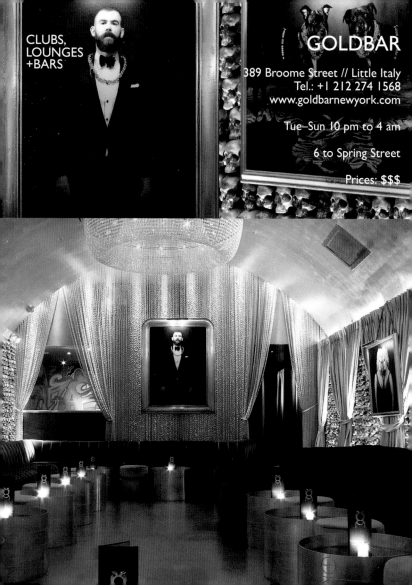

CLUBS,
LOUNGES
+BARS

GOLDBAR

389 Broome Street // Little Italy
Tel.: +1 212 274 1568
www.goldbarnewyork.com

Tue–Sun 10 pm to 4 am

6 to Spring Street

Prices: $$$

Gold as far as the eye can see. The vaulted ceiling is gold plated, wall decor consists of 2,400 specially made and gilded miniature skulls. Rows of heavy rapper's chains function as curtains and the drum tables look like stacked Cartier love bracelets. Even the turntables at the DJ station shine in golden radiance. The honey-based cocktails not only match the color, they're also delicious.

Gold so weit das Auge reicht. Das Deckengewölbe ist goldbeschichtet, das Wanddekor besteht aus 2 400 eigens angefertigten, vergoldeten Miniaturtotenköpfen. Reihen schwerer Rapperketten bilden die Vorhänge, und die Trommeltische sehen wie aufeinandergeschichtete Love-Armbänder von Cartier aus. Selbst die Plattenteller im DJ-Pult erstrahlen in goldenem Glanz. Nicht nur farbkoordiniert, sondern auch köstlich sind die Cocktails auf Honigbasis.

De l'or à perte de vue ! Le plafond voûté est recouvert d'or, la décoration murale est composée de 2 400 têtes de mort miniatures dorées, réalisées spécialement pour l'établissement. Des rangées de lourdes chaînes de rappeurs font office de rideaux et les guéridons font penser à des bracelets Love de Cartier superposés. Même les platines du pupitre DJ arborent une sublime dorure. Les cocktails, confectionnés sur une base de miel, sont parfaitement coordonnés et surtout délicieux.

Oro hasta donde alcanza la vista. El techo abovedado está revestido de oro, la decoración de las paredes se compone de 2 400 calaveras doradas en miniatura, fabricadas expresamente. Filas de pesadas cadenas de rapero forman las cortinas, y las mesas tambor parecen pulseras del amor de Cartier apiladas. Incluso los platos en la mesa del DJ resplandecen en un brillo dorado. Los cócteles, preparados a base de miel, no solo combinan con el color, también son exquisitos.

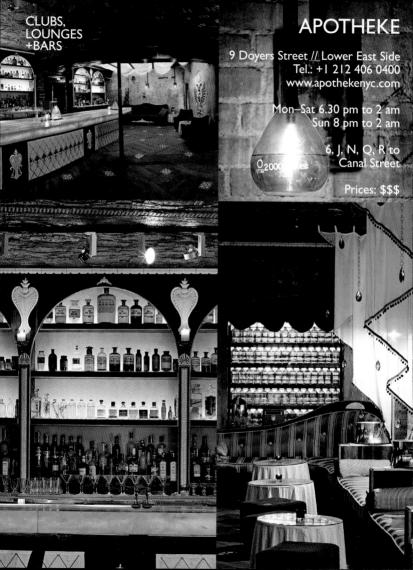

CLUBS,
LOUNGES
+BARS

APOTHEKE

9 Doyers Street // Lower East Side
Tel.: +1 212 406 0400
www.apothekenyc.com

Mon–Sat 6.30 pm to 2 am
Sun 8 pm to 2 am

6, J, N, Q, R to
Canal Street

Prices: $$$

Here, they have a magic potion for everything. The menu of over 200 exquisite cocktails is grouped in categories such as aphrodisiacs, pain relief, and health. Preparation of the drinks at the giant marble bar is celebrated every bit as much as their presentation in refined crystal goblets. Servers wear starched white aprons and the large glasses filled with herbs and elixirs complete the atmosphere.

Hier gibt es für alles einen Zaubertrank. Unter Kategorien wie Aphrodisiaka, Schmerzmittel oder Gesundheit stehen als 200 exquisite Cocktails auf der Karte. Die Zubereitung der Drinks an einer gigantischen Marmorbar wird ebenso zelebriert wie deren Präsentation in edlen Kristallschalen. Die Bedienungen tragen gestärkte weiße Kittel und große, mit Kräutern und Elixieren gefüllte Gläser vervollständigen das Ambiente.

Des potions magiques pour guérir tous les maux ! Que ce soit des aphrodisiaques, antidouleurs ou remèdes santé, la carte propose plus de 200 cocktails exquis. La préparation des boissons sur un gigantesque bar de marbre, tout comme leur présentation dans des coupes en cristal sont prodigieuses. Les serveurs portent des blouses blanches amidonnées et les grands verres remplis d'herbes et d'élixirs, accompagnés de mortiers, complètent cette atmosphère euphorique.

Aquí hay un elixir para todo. Más de 200 cócteles exquisitos llenan la carta, ordenados por categorías como afrodisiacos, analgésicos o salud. La preparación de las bebidas sobre una gigantesca barra de mármol está tan cuidada como su presentación en lujosos cuencos de cristal. Los camareros visten batas blancas almidonadas y los vasos con morteros, o llenos de hierbas o elixires, completan el ambiente.

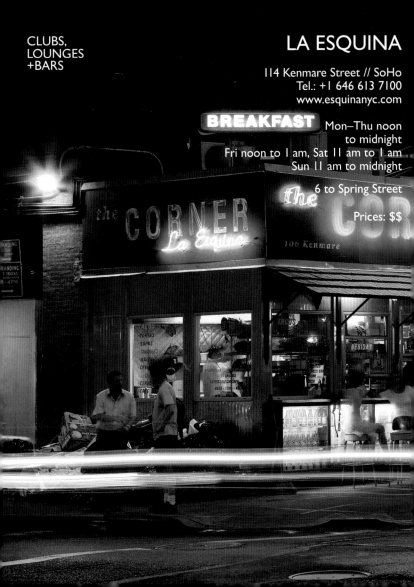

CLUBS,
LOUNGES
+BARS

LA ESQUINA

114 Kenmare Street // SoHo
Tel.: +1 646 613 7100
www.esquinanyc.com

BREAKFAST Mon–Thu noon
to midnight
Fri noon to 1 am, Sat 11 am to 1 am
Sun 11 am to midnight

6 to Spring Street

Prices: $$

From the street, the restored food truck looks like a Mexican snack bar with a few tables. But it functions as the façade for one of the most elegant and stylish restaurants in the city. Those in the know ignore the "Employees Only" sign and climb down the stairs to the underground basement vault. Weathered brick walls and Mexican tile mosaics are the decor for straightforward Mexican fare and more than 100 tequilas.

Von der Straße aus wirkt der restaurierte Speisewagen wie ein mexikanischer Schnellimbiss mit ein paar Tischen. Dabei fungiert er als Fassade für eines der elegantesten und stilvollsten Restaurants der Stadt. Eingeweihte ignorieren das Schild „Employees Only" und steigen hinab in ein unterirdisches Kellergewölbe. Verwitterte Ziegelmauern und mexikanische Kachelmosaiken sind das Dekor für schnörkellose mexikanische Küche und mehr als 100 Tequilas.

VALESCA GUERRAND HERMES'S SPECIAL TIP

An intriguing entrance and a cool crowd that clearly likes the nightlife.

Depuis la rue, le wagon-restaurant rénové, doté de quelques chaises, a une allure de snack mexicain. Pourtant, derrière cette façade se cache l'un des restaurants les plus élégants et stylés de la ville. Les initiés bravent l'écriteau « Employees Only » (Réservé aux employés) pour pénétrer dans une cave voûtée sous terre. Des murs de briques effrités et des carreaux de mosaïques offrent le décor parfait pour savourer une cuisine mexicaine sans fioritures et plus de 100 tequilas.

Desde la calle, el reformado local parece un snack-bar mexicano de comida rápida con un par de mesas. Sin embargo, es solo la fachada de uno de los más elegantes y refinados restaurantes de la ciudad. Los iniciados ignoran el letrero „Employees Only" y descienden hacia un sótano abovedado. Muros de ladrillo desmoronados y mosaicos de azulejos mexicanos componen la decoración para una cocina mexicana sin florituras y más de 100 tequilas diferentes.

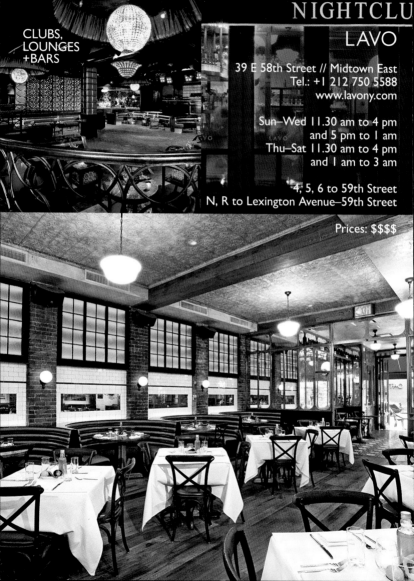

The New York offshoot of the happening Las Vegas club brings glamour and glitz to Park Avenue—not otherwise especially famous for its nightlife. The restaurant serves southern Italian delicacies, and go-go girls dance to techno beats in the downstairs lounge while disco balls flash above the sunken dance floor. Along with champagne by the bottle, the drinks menu also offers cocktails and beers.

Der New Yorker Ableger des angesagten Clubs in Las Vegas bringt Glamour und Glitzer auf die sonst nicht gerade für ihr Nightlife bekannte Park Avenue. Das Restaurant bietet süditalienische Köstlichkeiten, in der Lounge im Souterrain tanzen Go-go-Girls zu Techno-Beats, während Discokugeln über der tieferliegenden Tanzfläche blinken. Neben Champagner im Flaschenservice bietet die Getränkekarte auch Cocktails und Biere.

La filiale new-yorkaise du club branché de Las Vegas apporte glamour et éclat à la Park Avenue, qui n'est, à cette exception près, pas réputée pour sa vie nocturne. Le restaurant propose des spécialités délicieuses du Sud de l'Italie, des gogo girls ondulent au rythme des beats techno dans le lounge souterrain pendant que les boules à facettes clignotent au-dessus de la piste de danse en contrebas. Outre le champagne à la bouteille, la carte des boissons propose également cocktails et bières.

La sede principal de este afamado club se encuentra en Las Vegas. Su sucursal neoyorquina en Park Avenue aporta glamour y elegancia a una avenida que históricamente no ha destacado por su marcha nocturna. El restaurante ofrece delicias de la cocina italiana y en el lounge de la planta baja las gogó se contonean al son de la música electrónica bajo unas bolas de espejos que llenan de destellos la pista de baile. Aparte de botellas de champán, la carta de bebidas incluye también cócteles y cervezas.

CLUBS,
LOUNGES
+BARS

ASPEN
SOCIAL CLUB

157 W 47th Street // Midtown West
Tel.: +1 212 221 7200
www.aspensocialclub.com

Sun–Mon 8 am to midnight
Tue–Thu 8 am to 2 am
Fri–Sat 8 am to 4 am

1 to 50th Street
D, F to 47th–50th Streets

Prices: $$$

The menu of the restaurant and lounge at the Stay Hotel is, like the decor, rustic-eclectic and reflects Colorado's mountain character: bison burgers, venison sausages, and trout tacos. The warm and cozy log cabin design with giant antler chandelier and illuminated rows of trees behind glass is welcome relief from the neon hustle and bustle all around Times Square. Vegetarian diners can enjoy the cabin romance over cheese fondue.

Das Menü der Restaurant-Lounge im Stay Hotel ist wie die Einrichtung rustikal-eklektisch und reflektiert die Bergnatur Colorados: Büffelburger, Elchwürstchen und Forellentacos. Das warme, gemütliche Blockhüttendesign mit gigantischem Geweihkronleuchter und illuminierten Baumreihen hinter Glas ist eine willkommene Abwechslung zum Neontrubel rund um den Times Square. Vegetarische Gäste können die Hüttenromantik beim Käsefondue genießen.

Le menu de ce restaurant lounge du Stay Hotel est à l'image de la décoration, rustique et éclectique, et rappelle les montagnes du Colorado : hamburger de buffle, saucisse d'élan et tacos de truite. Le design chaleureux de style cabane en rondins avec lustres imposants en bois de cerfs et rangées d'arbres éclairés derrière des vitrines est une belle alternative à la profusion de néons autour de Times Square. Les végétariens profiteront du charme romantique des chalets autour d'une fondue au fromage.

El menú del restaurante-salón en el Stay Hotel es, como la decoración, rústico ecléctico y refleja la naturaleza montañosa de Colorado: hamburguesas de búfalo, salchichas de alce y tacos de trucha. El cálido y cómodo diseño de cabaña de madera, con lámparas de astas de ciervo gigantes y filas de árboles iluminados tras cristales, es una agradable alternativa frente al caos de neón en torno a Times Square. Los huéspedes vegetarianos pueden disfrutar de la romántica atmósfera de la cabaña con una fondue de queso.

CLUBS,
LOUNGES
+BARS

THE EAR INN

326 Spring Street // SoHo
Tel.: +1 212 431 9750
www.earinn.com

Daily noon to 4 am

1 to Canal Street
C, E to Spring Street

Prices: $$

Creaking boards, crooked stairs, and a touch of nostalgia create the charm of one of the oldest pubs in the city. Built in 1817, the landmark-protected building served dockworkers from the nearby piers starting in the mid-19th century. In the '70s Ear Magazine occupied one floor of the establishment, known up to that time as the "Green Door." The owners painted an E over the B in Bar, and since then the edited neon sign glows with the new name.

Quietschende Bohlen, schräge Treppen und ein Hauch Nostalgie machen den Charme einer der ältesten Kneipen der Stadt aus. Das denkmalgeschützte, 1817 erbaute Haus bewirtete ab Mitte des 19. Jahrhunderts Hafenarbeiter der umliegenden Piers. In den 70er Jahren bezog das Magazin Ear eine Etage des bislang als „Green Door" bekannten Lokals. Die Eigentümer übermalten das B in „Bar" mit einem E, und seitdem leuchtet das redigierte Neonschild mit neuem Namen.

Un plancher qui craque, un escalier de travers et un zeste de nostalgie font tout le charme de l'une des plus anciennes tavernes de la ville. Construit en 1817, cet établissement classé monument historique a commencé à servir les dockers qui travaillaient dans le coin dès la seconde moitié du XIXe siècle. Dans les années 70, le magazine Ear était installé à l'étage de ce café connu auparavant sous le nom de « Green Door ». Les propriétaires ont remplacé le B de « Bar » par un E. Depuis, l'enseigne lumineuse rayonne avec son nouveau nom.

Tablas chirriantes, escaleras inclinadas y una pizca de nostalgia son el encanto de uno de los bares más antiguos de la ciudad. La casa, construida en 1817 y monumento histórico protegido, acogía desde mediados del siglo XIX a trabajadores portuarios de los muelles cercanos. En los años 70, la revista Ear adquirió una planta del local, conocido hasta entonces como "Green Door". Los dueños pintaron una E sobre la B de "Bar" y desde entonces luce el letrero de neón corregido con el nuevo nombre.

CLUBS,
LOUNGES
+BARS

BEWARE
PICKPOCKETS
AND
LOOSE WOMEN

EMPLOYEES
ONLY

510 Hudson Street // West Village
Tel.: +1 212 242 302
www.employeesonlynyc.com

Daily 6 pm to 3.30 am

1 to Christopher Street

Prices: $$$

With its long, curving mahogany bar and engraved tin ceiling, the interior recalls memories of Prohibition-era speakeasies of the '20s. The staff is styled accordingly: center parts and pomade, handlebar moustaches and white dinner jackets. In summer the exquisite cocktails are also served in the little garden out back. A tarot reader provides entertainment in the foyer.

Das Interieur mit dem langen, geschwungenen Mahagonitresen und der gravierten Zinndecke ruft Erinnerungen an die Flüsterkneipen zu Zeiten der Prohibition in den 20er Jahren hervor. Entsprechend abgestimmt ist das Styling des Personals: Mittelscheitel und Pomade, Zwirbelbart und weiße Dinnerjackets. Die exquisiten Cocktails werden im Sommer auch in dem kleinen Garten hinter dem Haus serviert. Für Unterhaltung sorgt ein Tarotkartenleser im Foyer.

Avec son long comptoir courbé en acajou et son plafond en étain gravé, son intérieur rappelle les « speakeasies », ces bars clandestins durant la prohibition des années 20. Le style du personnel s'y accorde parfaitement: raie au milieu et gomina, moustache en guidon et veste de smoking blanche. En été, les délicieux cocktails sont également servis dans le petit jardin situé derrière l'établissement. Dans le hall, un tireur de cartes de tarot est là pour vous divertir.

El interior, con sus larga barra curva de caoba y el techo de estaño grabado, evoca recuerdos de los "speakeasy" durante la prohibición en los años 20. El estilo del personal está adaptado de forma conveniente: raya al medio y gomina, bigote imperial y esmóquines blancos. En verano, los exquisitos cócteles se sirven también en el pequeño jardín tras la casa. Del entretenimiento se ocupa un echador de cartas del tarot en el vestíbulo.

HIGHLIGHTS

COOL
NEW YORK

1980
THE NEW YORK AQUARIUM OPENS
90,000 GALLON SHARK TANK

1940
THE PARACHUTE JUMP,
STANDING 277 FEET TALL,
IS RELOCATED FROM
THE 1939 WORLD'S FAIR
TO STEEPLECHASE PARK

"IF PARIS IS FRANCE,
CONEY ISLAND, BETWEEN
JUNE AND SEPTEMBER,
IS **THE WORLD.**
–GEORGE TILYOU

CONEY ISLAND
+AQUARIUM
+NATHAN'S FAMOUS

1208 Surf Avenue // Brooklyn
Tel.: +1 718 373 5159
www.coneyisland.com

Rides and attractions daily from noon

D, F, N, Q to Coney Island–Stillwell Avenue

Prices: $$

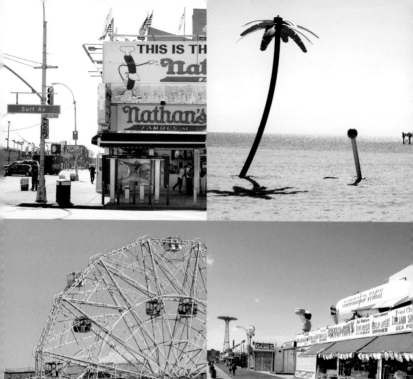

The 2.5 mi-long boardwalk with amusement parks, numerous snack bars and game booths has been a popular escape for New Yorkers with urban fatigue ever since its creation. Nathan Handwerker opened his first hot dog stand here in 1916, and the world's longest wooden roller-coaster, The Cyclone, began operating in 1927. A short walk along the beach leads to another attraction: the oldest continuously operating aquarium in the United States.

Die 4 km lange Strandpromenade mit Vergnügungsparks und vielen Imbiss- und Spielbuden ist seit ihrer Entstehung ein beliebtes Ausflugsziel für stadtmüde New Yorker. Nathan Handwerker eröffnete hier 1916 seinen ersten Hotdog-Stand, und die weltlängste Holzachterbahn, Cyclone, nahm 1927 ihren Betrieb auf. Ein kurzer Spaziergang am Strand entlang führt zu einer weiteren Attraktion, dem ältesten, durchgehend betriebenen Aquarium der USA.

La promenade de la plage qui s'étend sur 4 km est avec son parcs d'attractions, ses snacks et ses baraques foraines une destination d'excursion adulée des New-Yorkais fatigués de la ville, et ce depuis son apparition. En 1916, Nathan Handwerker ouvrit son premier stand de hot dogs et en 1927, Cylone, les plus longues montagnes russes en bois du monde furent mises en service. Une promenade le long de la plage vous emmène jusqu'au plus ancien aquarium des États-Unis, ouvert sans interruption depuis ses débuts.

El paseo marítimo de 4 km de largo, con parques de atracciones y multitud de puestos y casetas de juego, es desde su creación un destino apreciado por los neoyorquinos cansados de la ciudad. Nathan Handwerker abrió aquí en 1916 su primer puesto de perritos calientes, y la más larga montaña rusa de madera, Cyclone, comenzó a funcionar en 1927. Un corto paseo por la playa lleva a otra atracción, el acuario de los EE.UU. que más tiempo lleva abierto sin interrupción.

DUMBO

Brooklyn

A, C to High Street

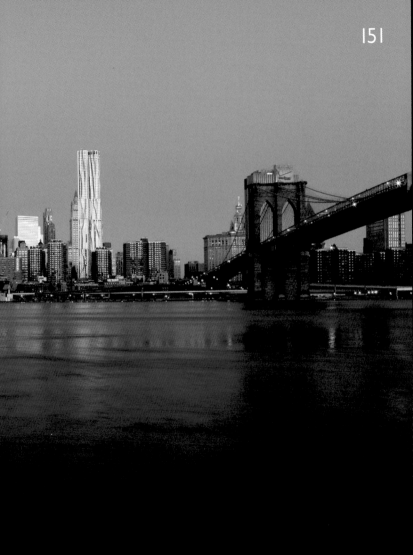

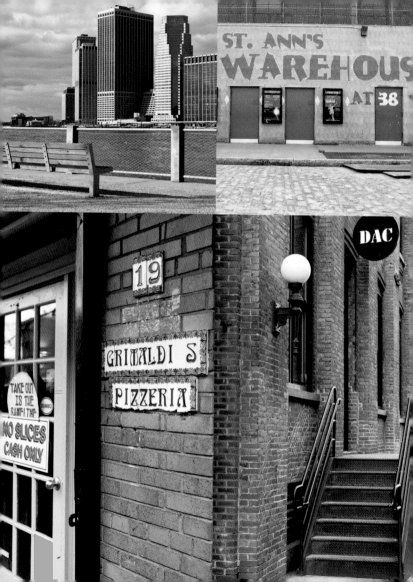

An activity that no one should miss is a walk across the Brooklyn Bridge, especially when combined with an exploratory tour through DUMBO, a formerly industrial neighborhood on the East River in Brooklyn. Right next to Brooklyn Bridge Park, which opened in 2010, is one of the legendary institutions that existed long before DUMBO was fashionable: Grimaldi's Pizzeria, where they still make the city's best wood-fired oven pizza.

Ein Ausflug, der nicht fehlen sollte, ist der Spaziergang über die Brooklyn Bridge, vor allem, wenn man ihn mit einer Entdeckungstour durch DUMBO verbindet, einem ehemaligen Industrieviertel am East River in Brooklyn. Gleich neben dem 2010 eröffneten Brooklyn Bridge Park befindet sich eine der legendären Institutionen, die bereits existierte, lange bevor DUMBO angesagt war: die Pizzeria Grimaldi's, wo es auch heute noch die beste Holzofenpizza der Stadt gibt.

La promenade sur le Brooklyn Bridge est à ne manquer sous aucun prétexte, surtout si on l'associe à un circuit découverte à travers DUMBO, l'ancien quartier industriel qui longe l'East River en Brooklyn. Juste à côté du Brooklyn Bridge Park, ouvert en 2010, se situe une institution légendaire qui existait déjà bien avant que DUMBO ne soit à la mode: la pizzeria Grimaldi's, qui propose aujourd'hui encore la meilleure pizza au feu de bois de la ville.

Una excursión que no puede faltar es el paseo por el Brooklyn Bridge, sobre todo si se combina con una expedición por DUMBO, un antiguo barrio industrial junto al East River en Brooklyn. Justo al lado del Brooklyn Bridge Park, abierto en 2010, se encuentra una de esas instituciones legendarias ya existentes mucho antes de que DUMBO se pusiera de moda: la pizzería Grimaldi's, donde aún hoy se prepara la mejor pizza en horno de leña de la ciudad.

THE HIGH LINE

Gansevoort Street to 34th Street between
Tenth and Eleventh Avenues // Meatpacking/Chelsea
Tel.: +1 212 500 6035
www.thehighline.org

Daily 7 am to 11 pm

A, C, E to 14th Street
L to 8th Avenue

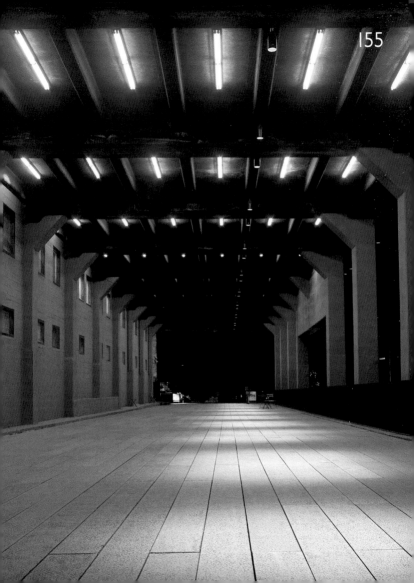

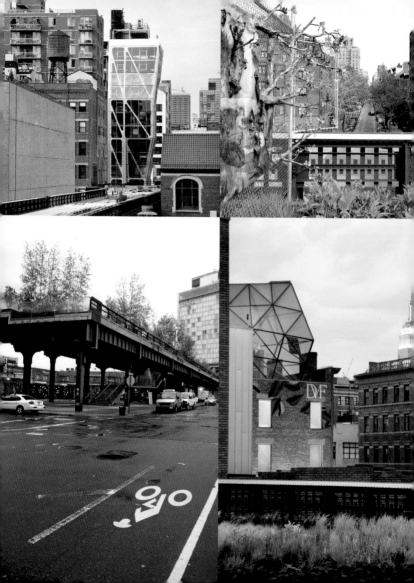

A decommissioned elevated railway on Manhattan's West Side that still carried freight traffic till 1980, The High Line was repurposed as a green oasis amid the sea of downtown buildings. 30 ft. above street-level, the train tracks were preserved and integrated into the design of the park over a distance of twenty blocks. Lounge chairs beckon sunbathers, and a window overlooking the avenue of traffic below turns the city into a stage.

Auf der stillgelegten Hochbahn im Westen Manhattans, auf der bis 1980 noch Güterzüge fuhren, entstand eine grüne Oase inmitten des Häusermeers in Downtown. Auf 10 m Höhe erstrecken sich die erhaltenen und in das Design des Parks integrierten Bahngleise über eine Länge von 20 Häuserblocks. Liegestühle laden zum Sonnenbaden ein, und eine Glasfront mit Aussicht auf die darunter vorbeiziehende Avenue lässt die Stadt zur Bühne werden.

VALESCA GUERRAND HERMES'S SPECIAL TIP

The High Line is the most exciting thing that's happened in New York in years.

En plein cœur des buildings de Downtown, un paradis de verdure a vu le jour sur les anciennes voies ferrées aériennes de l'Ouest de Manhattan, sur lesquelles des trains de marchandise circulaient jusqu'en 1980. Celles-ci ont été conservées et intégrées au design du parc et se déploient sur une 10 m de hauteur et sur une longueur de 20 blocs. Des chaises longues invitent à prendre un bain de soleil et à travers les baies vitrées surplombant l'avenue, la ville crève l'écran.

Sobre las vías elevadas abandonadas en el oeste de Manhattan, transitadas hasta 1980 por trenes de mercancías, surgió un oasis verde entre el mar de casas del Downtown. Las vías, conservadas e integradas en el diseño del parque, se extienden a 10 m de altura con una longitud de 20 manzanas. Las tumbonas invitan a tomar el sol y una fachada de cristal con vistas a la avenida que transcurre debajo convierte la ciudad en un escenario.

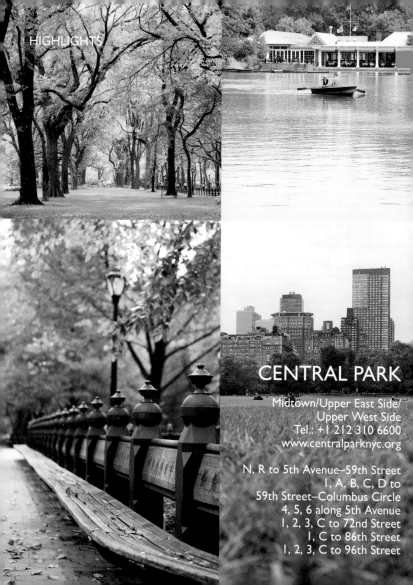

CENTRAL PARK

Midtown/Upper East Side/
Upper West Side
Tel.: +1 212 310 6600
www.centralparknyc.org

N, R to 5th Avenue–59th Street
1, A, B, C, D to
59th Street–Columbus Circle
4, 5, 6 along 5th Avenue
1, 2, 3, C to 72nd Street
1, C to 86th Street
1, 2, 3, C to 96th Street

The city's green oasis extends more than 50 blocks, and New Yorkers use it as a playground and athletic field from early in the morning till late in the evening and in all seasons. People meet to jog, skate, and play baseball. Quieter spots invite strolling or meditation. There are free concerts in summer. Situated in an idyllic location on the lake, the terrace of the Boathouse Restaurant is the perfect place for a drink or romantic dinner.

Über mehr als 50 Häuserblocks erstreckt sich die grüne Oase der Stadt, und New Yorker nutzen sie als Spielwiese und Sportanlage von früh bis spät und zu jeder Jahreszeit: Man trifft sich zum Joggen, Inlineskaten oder Baseball. Stillere Ecken laden zum Flanieren oder Meditieren ein. Im Sommer gibt es kostenlose Konzerte. Für einen Drink oder ein romantisches Dinner ist die Terrasse im Boathouse Restaurant in idyllischer Lage am See der perfekte Ort.

VALESCA GUERRAND HERMES'S SPECIAL TIP

A perfect afternoon date— dine outside at the Boat House, and then take a romantic boat ride on one of the paddle boats.

Ce havre de verdure s'étend sur une longueur de plus de 50 blocs d'immeubles. C'est pour les New-Yorkais une aire de jeux et un terrain de sport, où ils se rendent du matin au soir, en toutes saisons, pour faire un jogging, du roller ou jouer au baseball. Les coins plus tranquilles invitent à la flânerie ou la méditation. En été, place aux concerts gratuits. Pour prendre un verre ou savourer un dîner romantique dans un cadre idyllique au bord de l'eau, la terrasse du restaurant Boathouse est l'endroit idéal.

El oasis verde de la ciudad se extiende por más de 50 manzanas y los neoyorquinos lo utilizan como lugar para jugar y hacer deporte durante todo el día y en cualquier época del año: quedan para correr, patinar o jugar al baseball. Los rincones más tranquilos invitan a deambular o a meditar. En verano se celebran conciertos gratis. No hay lugar mejor para tomar una copa o tener una cena romántica que la terraza del restaurante Boathouse, con su idílica ubicación junto al lago.

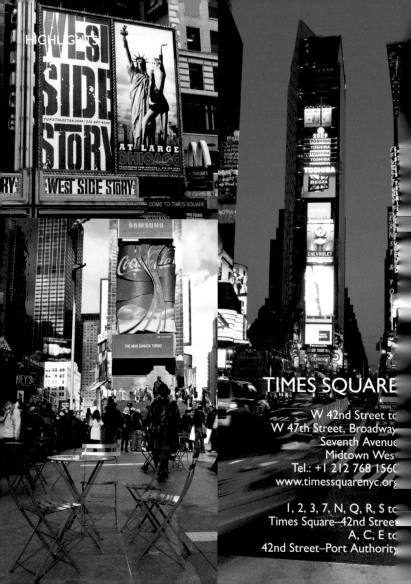

COME TO TIMES SQUARE

TIMES SQUARE

W 42nd Street to
W 47th Street, Broadway,
Seventh Avenue,
Midtown West
Tel.: +1 212 768 1560
www.timessquarenyc.org

1, 2, 3, 7, N, Q, R, S to
Times Square–42nd Street,
A, C, E to
42nd Street–Port Authority

With its countless enormous neon advertisements, display screens, and news tickers, the most famous intersection in the world, in the heart of the Theater District where Broadway meets Seventh Avenue, is an unmistakable piece of New York. Nowhere else can you better observe and experience the pulsing and exciting activity of the metropolis. Over 50 theaters, cinemas, comedy clubs, and restaurants provide round-the-clock entertainment.

Die berühmteste Kreuzung der Welt, im Herzen des Theaterdistrikts, wo sich Broadway und Seventh Avenue treffen, ist mit ihren unzähligen riesigen Neonreklamen, Bildschirmen und Newstickern ein unverwechselbares Stück New York. Nirgendwo sonst lässt sich das pulsierende, bunte Treiben der Metropole besser beobachten und erleben. Die mehr als 50 Schauspielhäuser, Kinos, Comedy Clubs und Restaurants bieten Unterhaltung rund um die Uhr.

Le carrefour le plus célèbre au monde se situe en plein cœur du quartier des théâtres, au point de rencontre de Broadway et de la Septième Avenue. Avec ses immenses néons publicitaires, ses écrans et bandeaux d'actualité à foison, cet endroit reflète tout simplement New York. Nulle part ailleurs, on ne peut aussi bien observer ni sentir battre le cœur de la métropole haute en couleurs. Plus de 50 théâtres, cinémas, comedy clubs et restaurants offrent un divertissement à toute heure du jour et de la nuit.

El cruce más famoso del mundo, en el corazón del distrito teatral, donde se encuentran Broadway y la Séptima Avenida, es con sus incontables y enormes anuncios de neón, pantallas y letreros informativos un trozo inconfundible de Nueva York. En ningún otro lugar se puede observar y vivir mejor la frenética y colorida actividad de la metrópolis. Los más de 50 teatros, cines, clubes de la comedia y restaurantes ofrecen entretenimiento a todas horas.

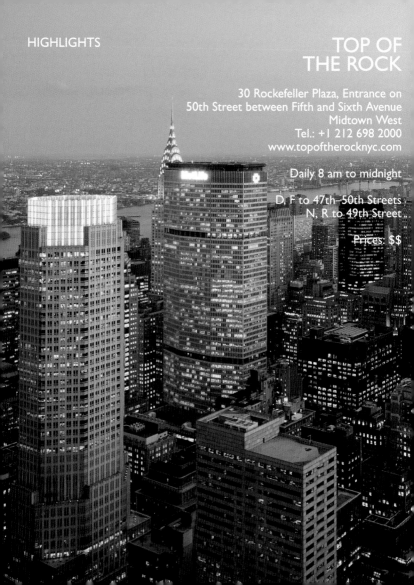

TOP OF
THE ROCK

30 Rockefeller Plaza, Entrance on
50th Street between Fifth and Sixth Avenue
Midtown West
Tel.: +1 212 698 2000
www.topoftherocknyc.com

Daily 8 am to midnight

D, F to 47th–50th Streets
N, R to 49th Street

Prices: $$

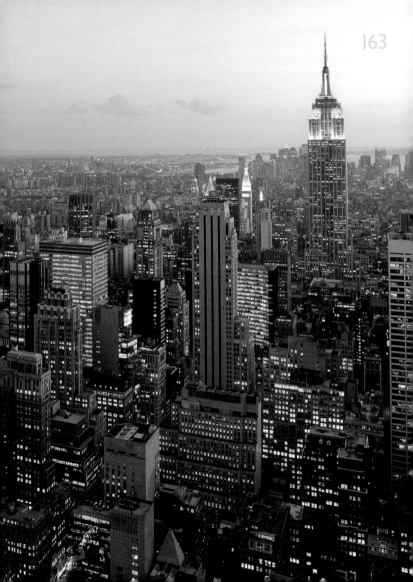

The ride in the glass-roofed elevator is already a breathtaking experience. It soars to the 70th floor of Rockefeller Center in just 50 seconds. On arrival at the observation platform of the world-famous art deco building you have an unparalleled 360-degree panoramic view of the city from 850 ft. up. No grille or fence impedes the view of Manhattan and environs from the top level of the three-story roof deck.

Schon die Fahrt im Aufzug mit seinem durchsichtigen Glasdach ist atemberaubend. In nur 50 Sekunden schnellt er bis zum 70. Stock des Rockefeller Centers. Auf der Aussichtsplattform des weltberühmten Art déco-Gebäudes angekommen, bietet sich in 260 m Höhe ein einzigartiger 360-Grad-Panoramablick auf die Stadt. Kein Gitter, kein Zaun behindert von der obersten Etage der dreistöckigen Dachterrasse die Aussicht auf Manhattan und Umgebung.

Avec son plafond de verre transparent, l'ascenseur offre déjà une montée à couper le souffle. En 50 secondes seulement, il file dans les airs pour atteindre le 70e étage du Rockefeller Center. Une fois sur la plate-forme panoramique du bâtiment Art déco connu dans le monde entier, s'offre à vous une vue unique à 360° sur la ville, le tout à 260 m de hauteur. Aucun grillage ni clôture, parfait pour contempler Manhattan et ses alentours depuis le dernier étage du toit-terrasse à trois étages.

El viaje en el ascensor, con su techo de cristal, es ya impresionante. En solo 50 segundos se catapulta hasta el piso 70 del Rockefeller Center. En la plataforma de observación del famoso edificio art déco, a 260 m de altura, se disfruta de una vista panorámica de 360° sobre la ciudad. En la tercera planta de la terraza de la azotea, no hay rejas o vallas que impidan disfrutar de las vistas de Manhattan y su entorno.

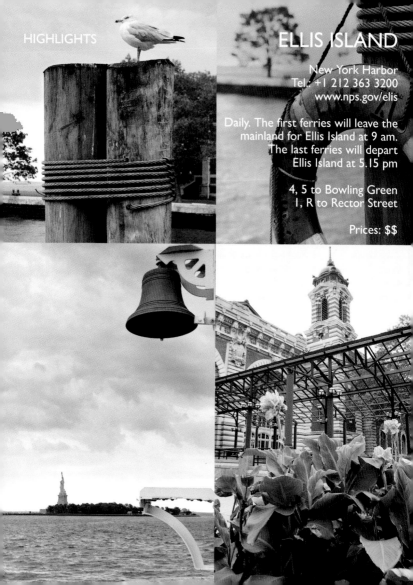

ELLIS ISLAND

New York Harbor
Tel.: +1 212 363 3200
www.nps.gov/elis

Daily. The first ferries will leave the
mainland for Ellis Island at 9 am.
The last ferries will depart
Ellis Island at 5.15 pm

4, 5 to Bowling Green
1, R to Rector Street

Prices: $$

Arriving at the transit camp on Ellis Island, newcomers saw in the symbol of the city their first glimpse of the New World. The reception station, where twelve million immigrants were registered from 1892 to the time it was closed in 1954, opened as a museum in 1976. In the restored arrival hall extensive registers and records as well as photographs and interactive displays present information on the origins and fates of the new arrivals.

Auf ihrem Weg zum Durchgangslager auf Ellis Island bot das Wahrzeichen der Stadt den Einwanderern den ersten Blick auf die Neue Welt. Die Auffangstelle, wo von 1892 bis zu ihrer Schließung 1954 zwölf Millionen Immigranten registriert wurden, eröffnete 1976 als Museumsstätte. In der restaurierten Ankunftshalle geben umfangreiche Register und Protokolle sowie Fotos und interaktive Displays Auskunft über Herkunft und Schicksale der Neuankömmlinge.

Dans la direction d'Ellis Island, l'emblème de la ville offrait aux immigrants la première perspective du nouveau monde. Le premier centre d'immigration, où douze millions d'immigrants ont été enregistrés de 1892 à 1954, année de sa fermeture, s'est reconverti en musée en 1976. Dans le hall d'accueil restauré, de nombreux documents et registres ainsi que des photos et des écrans interactifs livrent de précieuses informations sur l'origine et le destin des nouveaux arrivants.

En su camino hacia el campo de tránsito en Ellis Island, el símbolo de la ciudad ofrecía a los inmigrantes la primera imagen del nuevo mundo. El edificio de recepción, donde se registraron doce millones de inmigrantes desde 1892 hasta su cierre en 1954, abrió en 1976 como museo. En la sala de llegadas restaurada, extensos registros e informes, como también fotos y pantallas interactivas, dan testimonio de la procedencia y el destino de los recién llegados.

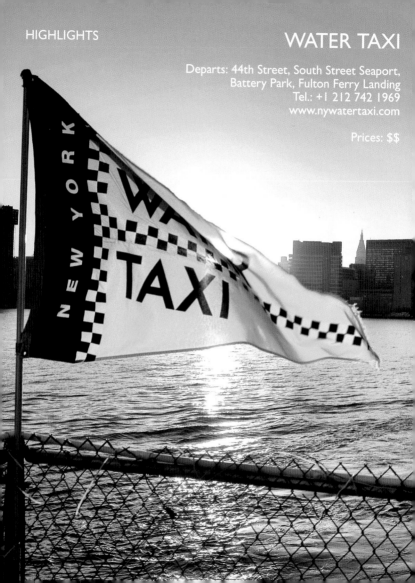

WATER TAXI

Departs: 44th Street, South Street Seaport,
Battery Park, Fulton Ferry Landing
Tel.: +1 212 742 1969
www.nywatertaxi.com

Prices: $$

The ferry service provides a pleasant alternative to the subway for getting from Manhattan to Brooklyn and Queens. Environmentally friendly double-decker catamarans ply the waters along the Hudson and East Rivers. There are several boarding locations in the three boroughs. Separate tours to the Statue of Liberty and harbor tours are also available. From seats on deck you have a fantastic view of the Manhattan skyline.

Der Fährservice bietet eine schöne Alternative zur Subway, um von Manhattan nach Brooklyn und Queens zu reisen. Die umweltfreundlichen Doppeldecker-Katamarane pendeln entlang Hudson und East River. Zustieg ist an mehreren Anlegestellen in den drei Bezirken möglich. Daneben gibt es Extratouren zur Freiheitsstatue und Hafenrundfahrten. Von den mit Sitzplätzen ausgestatteten Decks bietet sich ein traumhafter Blick auf die Skyline Manhattans.

Le bateau-taxi offre une belle alternative au métro pour rejoindre Brooklyn et le Queens en partant de Manhattan. Les catamarans à deux étages, respectueux de l'environnement, naviguent le long de l'Hudson et de l'East River. Les trois circonscriptions comptent plusieurs embarcadères. De plus, des navettes spéciales vous emmènent à la Statue de la Liberté ou vous font faire le tour du port. Depuis les sièges situés sur le pont, la vue sur la ligne d'horizon de Manhattan est idyllique.

El servicio de ferris ofrece una bonita alternativa al metro para viajar de Manhattan a Brooklyn y Queens. Los catamaranes de dos cubiertas, respetuosos con el medio ambiente, transitan por el Hudson y el East River. Existen varios embarcaderos en los tres distritos. Además, se ofrecen pasajes extra a la Estatua de la Libertad y vueltas por el puerto. Desde las cubiertas con asientos se presenta una vista de ensueño del panorama urbano de Manhattan.

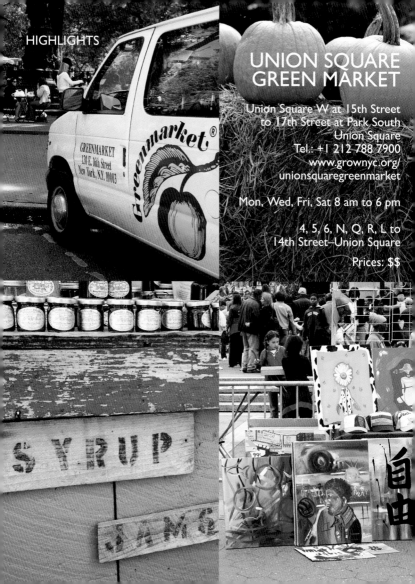

HIGHLIGHTS

UNION SQUARE GREEN MARKET

Union Square W at 15th Street
to 17th Street at Park South
Union Square
Tel.: +1 212 788 7900
www.grownyc.org/
unionsquaregreenmarket

Mon, Wed, Fri, Sat 8 am to 6 pm

4, 5, 6, N, Q, R, L to
14th Street–Union Square

Prices: $$

What began in 1976 with a handful of farmers has developed over the years into the city's largest farmers' market. More than 140 growers sell their own produce in an area of 86,000 sq. ft.: organic fruits and vegetables, handmade cheese, homemade preserves, and a wide variety of seasonal produce. Due to the outstanding quality of the products and the large selection, even the star chefs from nearby restaurants buy their ingredients here.

Was 1976 mit einer Handvoll Farmern anfing, hat sich über die Jahre zum größten Wochenmarkt der Stadt entwickelt. Auf 8 000 m² bieten mehr als 140 Erzeuger ihre Waren aus eigenem Anbau an: organisches Obst und Gemüse, von Hand hergestellter Käse, hausgemachte Marmeladen und vielerlei saisonale Produkte. Dank der hervorragenden Qualität der Erzeugnisse sowie der großen Auswahl kaufen auch die Starköche der umliegenden Restaurants hier ihre Zutaten.

Ce marché qui a débuté en 1976 avec quelques fermiers est devenu au fil des années le plus grand marché hebdomadaire de la ville. Sur un espace de 8 000 m², plus de 140 producteurs y vendent leurs produits : fruits et légumes, fromages artisanaux, confitures faites maison et de nombreux produits de saison. L'excellente qualité des produits et le vaste choix attirent également les grands chefs des restaurants environnants qui viennent s'y fournir.

Lo que comenzó en 1976 con un puñado de granjeros, se ha convertido con los años en el mercado semanal más grande de la ciudad. En una superficie de 8 000 m², más de 140 productores ofrecen sus propias mercancías: frutas y verduras orgánicas, queso hecho a mano, mermeladas caseras y muchos productos de temporada. Gracias a la gran calidad de los productos y a la enorme variedad, los cocineros estrella de los restaurantes cercanos compran aquí sus ingredientes.

 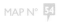

THE CLOISTERS
MUSEUM
AND GARDENS

99 Margaret Corbin Drive // Washington Heights
Tel.: +1 212 923 3700
www.metmuseum.org/cloisters

Tue–Sun 9.30 to 5.15 pm

A to 190th Street

Prices: $$

The museum for medieval art in northern Manhattan, a branch of the Metropolitan Museum of Art, houses over 5,000 works, mostly from the 12th century, including rare tapestries and stained glass. The castle-like museum and its vaulted passageways were created by disassembling parts of European abbeys and rebuilding them here in their original form. The garden, created in accordance with medieval writings, affords a unique view of the Hudson River.

Das Museum für mittelalterliche Kunst im Norden Manhattans, ein Ableger des Metropolitan Museum of Art, beherbergt über 5 000 Werke zumeist aus dem 12. Jahrhundert, darunter rare Wandteppiche und Glasmalereien. Für das schlossartige Museum mit seinen Gewölbegängen wurden Teile europäischer Abteien zerlegt und originalgetreu wiederaufgebaut. Der nach mittelalterlichen Schriften angelegte Garten erlaubt einen einmaligen Blick über den Hudson.

The Cloisters, musée situé au nord de Manhattan, est une annexe du Metropolitan Museum of Art, consacrée à l'art médiéval. Il abrite environ 5 000 œuvres, pour la plupart du XIIe siècle, et compte des tapisseries rares et des peintures sur verre. Pour ce musée aux allures de château arborant de superbes voûtes, des éléments d'abbayes européennes ont été démontés et reconstruits fidèlement à l'original. Le jardin, aménagé d'après des écrits médiévaux, offre une vue unique sur l'Hudson.

El museo de arte medieval en el norte de Manhattan, perteneciente al Metropolitan Museum of Art, guarda más de 5 000 obras, en su mayoría del siglo XII, entre ellas raros tapices y pinturas sobre vidrio. Para el museo-castillo de pasillos abovedados se desarmaron trozos de abadías europeas y se reconstruyeron aquí con todo detalle. El jardín, planificado siguiendo escrituras medievales, ofrece unas vistas únicas sobre el Hudson.

COOL
DISTRICTS

UPPER EAST SIDE / UPPER WEST SIDE
Uptown Manhattan east and west of Central Park boasts a dozen world-class cultural institutions. Designer boutiques and fine restaurants add to each area's charm with its restored townhouses and elegant pre-war architecture.

MIDTOWN / HELL'S KITCHEN
An array of skyscrapers marks the world's most famous skyline. Hell's Kitchen, west of Broadway, has shed its seedy past and emerged as a vibrant neighborhood with many trendy and affordable restaurants.

MEATPACKING DISTRICT / WEST VILLAGE / CHELSEA
The Meatpacking District is often considered the city's most fashionable neighborhood full of exclusive clubs. The bohemian West Village features endless dining and entertainment options. And with over 300 galleries, Chelsea is the nation's unrivaled art capital.

EAST VILLAGE / UNION SQUARE / FLATIRON
Known for its arts community and funky shops, the quirky East Village has the city's highest concentration of bars. The historic intersection at Union Square is the place to meet the city's top chefs on their shopping trip at Manhattan's famous open-air Greenmarket.

LOWER EAST SIDE
With an influx of style-conscious professionals, both neighborhoods have been transformed from gritty to glamorous with an eclectic mix of funky bars, stylish restaurants, avant-garde fashion, and live-music venues.

SOHO / TRIBECA
Once home to artists who turned the neighborhood's industrial lofts into art studios, SoHo has become one of the city's most lively shopping areas. Converted industrial buildings and waterfront access make TriBeCa a haven for sophisticated urbanites.

FINANCIAL DISTRICT / NEW YORK HARBOR / SOUTH STREET SEAPORT
The home of Wall Street is one of the city's oldest and most historic neighborhoods. Landmark buildings stand in contrast to modern skyscrapers and the harbor offers spectacular views of the Brooklyn Bridge.

BROOKLYN / CONEY ISLAND / DUMBO
Brooklyn's diverse and culturally rich environment has always nurtured innovation and creativity. DUMBO has made a name for itself as New York's Digital District. The historic seaside resort of Coney Island at Brooklyn's southern tip offers a welcome respite from the city's bustle.

COOL
MAP

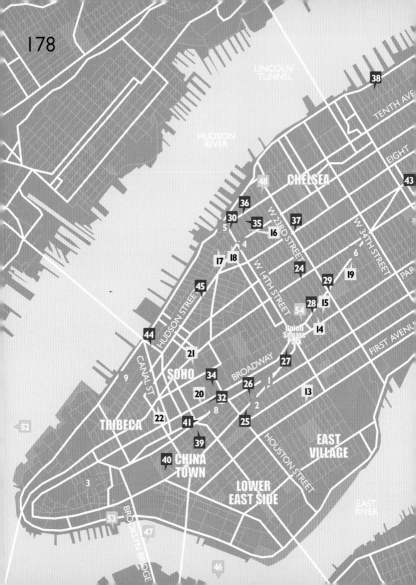

EMERGENCY

Emergency number for Fire,
Police, Ambulance Tel.: 911

ARRIVAL

BY PLANE

JOHN F. KENNEDY
INTERNATIONAL AIRPORT (JFK)
15 miles / 24 km east of the city center.
National and international flights. Shuttle
bus service or Air Train available into
Midtown Manhattan. For the Air Train or
the subway into the city change trains
at either Howard Beach (to subway A)
or Jamaica Station (to subway E, J, Z,
or the Long Island Rail Road).

NEWARK LIBERTY
INTERNATIONAL AIRPORT (EWR)
16 miles / 26 km west of the city center.
National and international flights.
Newark Liberty Airport Express runs
every 15 minutes to Manhattan
(Port Authority Bus Terminal,
Bryant Park, Grand Central Station).
www.panynj.gov
for more airport information

TOURIST INFORMATION

OFFICIAL NEW YORK CITY MARKETING AND TOURISM ORGANIZATION NYC & COMPANY
810 Seventh Avenue New York, NY 10019
Tel.: +1 212 484 1200

www.nycgo.com
Mon–Fri 8.30 am to 6 pm,
Sat–Sun 9 am to 5 pm
New York Information Kiosks are located at:
Whitehall Ferry Terminal (South of Battery
Park), World Trade Center PATH Station
(Church and Vesey Streets), NYC Heritage
Tourism Center (Southern tip of City Hall
Park on the Broadway sidewalk at Park Row),
Chinatown (Triangle between Canal, Baxter,
and Walker Streets)
www.nyc.gov
official website of New York City
www.iloveny.com
New York State Division of Tourism website
www.ny.com

ACCOMMODATION

www.hotels.com – hotel booking service
www.nyhabitat.com
hotels, bed & breakfast, rooms, etc.
www.newyork.craigslist.org – insider tip for
finding short-term sublets

COOL
CITY INFO

www.priceline.com
hotel bookings with bidding feature
www.tripadvisor.com
best hotel reviews with top value listing
www.newyorkstay.com
one-stop website for all accommodation
needs from hostel bed to penthouse

TICKETS

www.ticketmaster.com – wide range
of tickets for concerts, theater, culture
and sporting, and other events in
New York City
www.tdf.org – discount tickets with
reductions of 25%, 35% and 50% for
Broadway and Off-Broadway shows,
for dance performances and musicals
www.citypass.com – 50% entrance
discount and no waiting times in the
following locations: Empire State Building,
MoMA, Guggenheim Museum,
The Metropolitan Museum of Art,
and American Museum of Natural History
as well as the 2-hour Circle Line boat tour
www.mta.info/metrocard
unlimited use of subway, Staten Island
Railway and the city buses with the
Unlimited Ride MetroCard for one-day
or 7-day tickets

GETTING AROUND

PUBLIC TRANSPORTATION
www.hopstop.com
online city transit guide
www.mta.info/nyct
Metropolitan Transportation Authority
Tel.: +1 718 330 1234

TAXI
Normally cabs can be stopped by
waving the hand when the number on
the roof is lit. Use only yellow taxis that
are licensed and equipped with a taxi meter.
Taxi and Limousine Commission
Tel.: +1 212 302 8294

BICYCLE RENTALS
Rental bikes are available in various shops
around Central Park, through several bike
shop locations throughout the city, such as
www.masterbikeshop.com, or Pier 84 along
the Hudson River Greenway for
www.bikeandroll.com
For a complete listing go online at
www.bikenewyork.org – under Local Info.

CAR RENTAL
www.zipcar.com – Besides the international
rental car companies, Zipcar rental agency is
an online membership car club service that
allows users to share cars either by the day
or on an hourly basis from cars parked
throughout the city

CITY TOURS

The most inexpensive way to tour
Manhattan is with the M1 bus from
East 8th Street/4th Avenue
(Mon–Fri also from South Ferry) to
West 146th Street in Harlem and back.
Using the subway is another great way
to explore the different neighborhoods
all throughout Manhattan by stopping at
major stations and traveling by foot.

SIGHTSEEING BUSES
www.experiencetheride.com
new immersive and interactive enter-
tainment experience that turns the
streets of New York into a stage, busses
are designed with more than 3,000 LED
lights and 40 video screens and three rows
of stadium seats, famous NYC landmarks
become backdrops to a live show that plays
out right in front of riders
Tel.: +1 646 289 5080
www.graylinenewyork.com
uptown and downtown routes including
specially themed tours such as the Holiday
Lights Tour
Tel.: +1 212 445 0848
www.citysightsny.com
hop-on, hop-off double-decker bus tours
Tel.: +1 212 812 2700
www.newyorkpartyshuttle.com
OnBoard New York Sightseeing Tours
Tel.: +1 212 852 4821

BOAT TOURS
www.circleline42.com
Circle Line Sightseeing Cruises
Tel.: +1 212 563 3200
www.circlelinedowntown.com
Circle Line Downtown
Tel.: +1 212 269 5755
www.nywatertaxi.com
New York Water Taxi
Tel.: +1 212 742 1969
www.siferry.com
Staten Island Ferry
Tel.: +1 718 727 2508

GUIDED TOURS
www.bigapplegreeter.org
Big Apple Greeter
Tel.: +1 212 669 8159 – people from
New York provide a free guided tour for
visitors through their city
www.bigonion.com
Big Onion Walking Tours
Tel.: +1 888 606 9255
competently guided walkabouts con-
centrating on special aspects and topics with
themed tours
www.nyculinarytours.com
New York Culinary Tours
Tel.: +1 212 956 0862
tours through ethnic enclaves in all
five boroughs to savor the many tastes
and smells of each neighborhood

COOL
CITY INFO

www.shopgotham.com
New York Shopping Tours
Tel.: +1 212 209 3370 – Shop Gotham
shopping tours provides insider access,
exclusive store discounts and exciting
perks not available to the independent
fashion shopper
www.nycwalk.com
New York City Cultural Walking Tours
Tel.: +1 212 979 2388 – tours cover such
diverse topics as gargoyles on buildings and
the old Yiddish theaters of the East Village
www.bikethebigapple.com
Bicycle Tours throughout all the 5 boroughs
Tel.: +1 347 878 9809 – tours offered on
Fridays, Saturdays, and Sundays
that last 4–7 hours

ART & CULTURE

www.nyc-arts.org – art events calendar
www.nyc.com/events
culture events calendar
www.new.york.eventguide.com
event guide
www.nymag.com/agenda
New York magazine culture calendar
www.artinfo.com/galleryguide
guide to galleries in New York
www.nyc-architecture.com
information on significant monuments
in New York
www.playbill.com
Playbill's Official Website
www.broadway.com – comprehensive
source for all Broadway shows

GOING OUT

www.villagevoice.com
city's most popular city magazine
with in-scene news
www.newyorktimes.com
event calendar, online ticket service,
restaurant search engine, and more
city entertainment information online
www.nymag.com
covers the arts, entertainment, fashion,
and food as well as a special section that
features what is happening weekly
www.timeoutny.com
the bible for entertainment in NYC
www.newyork.citysearch.com
guide to dining, clubbing, shopping,
attractions, and events

EVENTS

JANUARY TO MARCH
www.whitney.org
the Whitney Biennial is one of the
leading annual exhibitions of contemporary
art in the nation from February to May
www.thearmoryshow.com
the highly acclaimed Armory Show is
America's leading contemporary fine art fair
www.jalc.org
the annual Sing into Spring festival at Jazz at
Lincoln Center features the full spectrum
of jazz singing with performances by some
of the biggest names in jazz

COOL
CITY INFO

APRIL TO JUNE

www.tribecafilmfestival.org
an international film festival that takes place
in spring every year in lower Manhattan

www.nyphotofestival.com
five-day event celebrating contemporary
photography in New York's new photo
district DUMBO, Brooklyn

bikenewyork.org
The best way to explore all of
New York City in a day is on your own two
wheels. The ride is 42 miles/68 km long

www.hellskitchen.bz
Hell's Kitchen's annual food festival,
where restaurants and outdoor vendors
serve up food to suit every taste

www.shakespeareinthepark.org
free performances in Central Park

JULY TO SEPTEMBER

www.museummilefestival.org
nine of America's best museums
82nd Street to 105th Street with entertain-
ment and free access to all museums

www.rivertorivernyc.com
the River to River Festival takes place
in Lower Manhattan with a host of free
events taking place from June to August

www.lincolncenter.org
the Lincoln Center Festival hosts various
dance, music, opera, circus, and theater
performances from around the world
during July

www.summerstage.org
free performances by international artists and
big name benefit shows on the main stage in
Central Park and around the city from June to
September

www.filmlinc.com
the coveted New York Film Festival takes place
in the Lincoln Center in late September with
cinematic works by filmmakers from
around the world

www.harlemweek.com
the month-long annual celebration features
performances, vendors, and tributes at
assorted venues

OCTOBER TO DECEMBER

www.ohny.org
hosts year-round programs celebrating
New York City's built environment
ending with an annual weekend celebration
as America's largest architecture and
design event

chocolateshow.com
annual Chocolate Show, a full-on chocolate
expo, full of inventive live demonstrations,
samples, book signings, and more

www.nycomedyfestival.com
all the big names in comedy grace
a New York stage at small venues and
large-scale shows at venues like Radio
City Music Hall and Carnegie Hall

COOL
CREDITS

COVER by Roland Bauer
Back cover photos courtesy LHW/Plaza Athenée, Lizzy Courage, Timothy Hursley
Illustrations by Lizzy Courage

p 2–3 (mood) by Martin N. Kunz
(further credited as mnk)
p 6–7 (The Museum of Modern Art) by Timothy Hursley
p 8–9 (Graffiti) by Lizzy Courage
(further credited as lc)

HOTELS

p 12–14 (The Cooper Square Hotel) p 12 by lc; other photos by mnk; p 16 (Lafayette House) all photos courtesy of Lafayette; p 18–20 (Gild Hall) p 18–19 and 20 left and right bottom by Michael Weber, all courtesy of Thompson Hotels; p 22–24 (Soho House) p 22–23 and 24 left top and bottom by Jenny Acheson, p 24 right by Amy Murrell; p 26–28 (The Standard Hotel) p 26, p 28 left top and bottom by Nikolas Koenig, p 27 and p 28 right top by mnk; p 30–32 (Ace Hotel) all photos by mnk; p 34 (Chambers Hotel) left top and left bottom by Roland Bauer (further credited as rb) and mnk, right top and right bottom courtesy of Chambers Hotel; p 36–38 (Crosby Street Hotel) p 38 left top by lc, all other by mnk; p 40–42 (The Greenwich Hotel) p 42 left bottom courtesy of The Greenwich Hotel, all other by mnk; p 44–46 (Plaza Athénée) all photos courtesy of LHW/Plaza Athénée; p 48 (The Carlyle) all photos courtesy of Rosewood Hotels & Resorts; p 50–52 (The Mark) p 50-51 and 52 right top and left bottom by Todd Eberle, p 52 left top and right bottom by Julie Glassberg

RESTAURANTS +CAFÉS

p 56 (Momofuku) all photos by Noah Kalina; p 58–60 (ABC Kitchen) all photos by Claudia Hehr (further credited as ch); p 62 (Mari Vanna) all photos by Michael Bernadsky; p 64 (Buddakan) courtesy of Starr Restaurants; p 66–68 (MPD) all photos by Rob Loud; p 70–73 (Spice Market) all photos by mnk; p 74–76 (The Breslin) p 76 right bottom by Melissa Horn, all other by mnk; p 78 (Balthazar) left top and bottom by ch, other courtesy of Balthazar; p 80 (Raoul's) all photos by ch; p 82 (Macao) all photos courtesy of Macao; p 84 (Amaranth) all photos by ch

SHOPS

p 90–92 (Limelight Marketplace) p 90–91 by lc, p 92 by mnk; p 94 (John Varvatos) all photos courtesy of John Varvatos; p 96 (Partners & Spade) left top and right by Devon Jarvis Studio 2009, left bottom by Nico Arrelano; p 98 (Strand Bookstore) all photos by ch; p 100 (ABC Carpet & Home) all photos by rb; p 102 (Eataly) all photos by Evan Sung; p 104 (Jeffrey New York) all photos by rb; p 106 (Fao Schwarz) left top and left bottom by mnk; p 108 (MoMA Design and Book Store) all photos by rb; p 110 (Tommy Hilfiger Flahship Store) all photos courtesy of Tommy Hilfiger; p 112 (Marc Jacobs) all photos courtesy of Marc Jacobs

CLUBS, LOUNGES +BARS

p 116 (10AK) all photos courtesy of 10AK; p 118 (Avenue) all photos courtesy of Avenue; p 120 (The Chelsea Room) all photos courtesy of Chelsea Room; p 122–124 (Hudson Terrace) all photos by ch; p 126 (Goldbar) all photos courtesy of Goldbar; p 128 (Apotheke) all photos courtesy of Apotheke; p 130–132 (La Esquina) all photos by ch; p 134 (Lavo) all photos courtesy of Lavo; p 136 (Aspen Social Club) all photos courtesy of Aspen Social Club; p 138 (The Ear Inn) all photos by ch; p 140 (Employees Only) all photos by Helen Brandshaft

HIGHLIGHTS

p 146–148 (Coney Island) all photos by ch; p 150–152 (DUMBO) all photos by ch; p 154–156 (The High Line) p 154–155 by lc, p 156 by mnk; p 158 (Central Park) all photos by ch; p 160 (Times Square) all photos by ch; p 162–164 (Top of the Rock) p 164 right top and left bottom by ch, all other by mnk; p 166 (Ellis Island) all photos by ch; p 168–170 (Water Taxi) all photos by ch; p 172 (Union Square Green Market) right bottom by mnk, all other by ch; p 174 (The Cloisters Museum & Gardens) all photos by ch; p 190 (Graffiti) by mnk

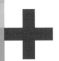

ART
ARCHITECTURE
DESIGN

Pocket-size Book
www.aadguide.com

ISBN 978-3-8327-9501-6

ISBN 978-3-8327-9499-6

ISBN 978-3-8327-9435-4

ISBN 978-3-8327-9463-7

ISBN 978-3-8327-9464-4

ISBN 978-3-8327-9434-7

ISBN 978-3-8327-9465-1

ISBN 978-3-8327-9502-3

A NEW GENERATION

of multimedia travel guides featuring
the ultimate selection of architectural
icons, galleries, museums, stylish
hotels, and shops for cultural and
art-conscious travelers.

VISUAL

Immerse yourself into inspiring
locations with photos and videos.

ISBN 978-3-8327-9433-0

COPENHAGEN
BARCELONA
SHANGHAI
TOKYO
SINGAPORE
BEIJING
VIENNA
PARIS
SYDNEY
HONG KONG
MUNICH
ZURICH
NEW YORK
SAO PAULO
AMSTERDAM
MIAMI
FRANKFURT
HAMBURG
LONDON
ROME
EMIRATES
CHICAGO
MILAN
BERLIN

COOL
CITIES

Pocket-size Book
App for iPhone/iPad/iPod Touch
www.cool-cities.com

ISBN 978-3-8327-9484-2

ISBN 978-3-8327-9595-5

ISBN 978-3-8327-9497-2

ISBN 978-3-8327-9488-0

ISBN 978-3-8327-9490-3

ISBN 978-3-8327-9496-5

ISBN 978-3-8327-9489-7

ISBN 978-3-8327-9493-4

ISBN 978-3-8327-9491-0

A NEW GENERATION

of multimedia lifestyle travel guides featuring the hippest, most fashionable hotels, shops, dining spots, galleries, and more for cosmopolitan travelers.

VISUAL

Discover the city with tons of brilliant photos and videos.

APP FEATURES

Search by categories, districts, or geolocator; get directions or create your own tour.

© 2011 Idea & concept by Martin Nicholas Kunz, Lizzy Courage Berlin
Selected by Patrice Farameh, Désirée von LaValette,
Anuschka Tomat and Martin Nicholas Kunz
Edited by Anuschka Tomat, (Intro) Patrice Farameh // Editorial coordination: Sina Milde
Photo Editor: David Burghardt
Copy editing: Inga Wortmann
Art direction: Lizzy Courage Berlin
Design Assistant: Sonja Oehmke
Imaging and pre-press: mace.Stuttgart
Translations: Übersetzungsbüro RR Communications Romina Russo,
Robert Rosenbaum, Romina Russo (English),
Samantha Michaux, Élodie Gallois (French), Bruno Plaza, Romina Russo (Spanish)

© 2011 teNeues Verlag GmbH + Co. KG, Kempen

teNeues Verlag GmbH + Co. KG
Am Selder 37, 47906 Kempen // Germany
Phone: +49 (0)2152 916-0, Fax: +49 (0)2152 916-111
e-mail: books@teneues.de

Press department: Andrea Rehn
Phone: +49 (0)2152 916-202 // e-mail: arehn@teneues.de

teNeues Digital Media GmbH
Kohlfurter Straße 41–43, 10999 Berlin // Germany
Phone: +49 (0)30 700 77 65-0

teNeues Publishing Company
7 West 18th Street, New York, NY 10011 // USA
Phone: +1 212 627 9090, Fax: +1 212 627 9511

teNeues Publishing UK Ltd.
21 Marlowe Court, Lymer Avenue, London SE19 1LP // UK
Phone: +44 (0)20 8670 7522, Fax: +44 (0)20 8670 7523

teNeues France S.A.R.L.
39, rue des Billets, 18250 Henrichemont // France
Phone: +33 (0)2 4826 9348, Fax: +33 (0)1 7072 3482

www.teneues.com

Bibliographic information published by the Deutsche Nationalbibliothek.
The Deutsche Nationalbibliothek lists this publication in the
Deutsche Nationalbibliografie; detailed bibliographic data are
available in the Internet at http://dnb.d-nb.de.

Printed in the Czech Republic
ISBN: 978-3-8327-9484-2

MIX
Papier aus verantwortungsvollen Quellen
Paper from responsible sources
FSC® C005833